WALTER SICKERT

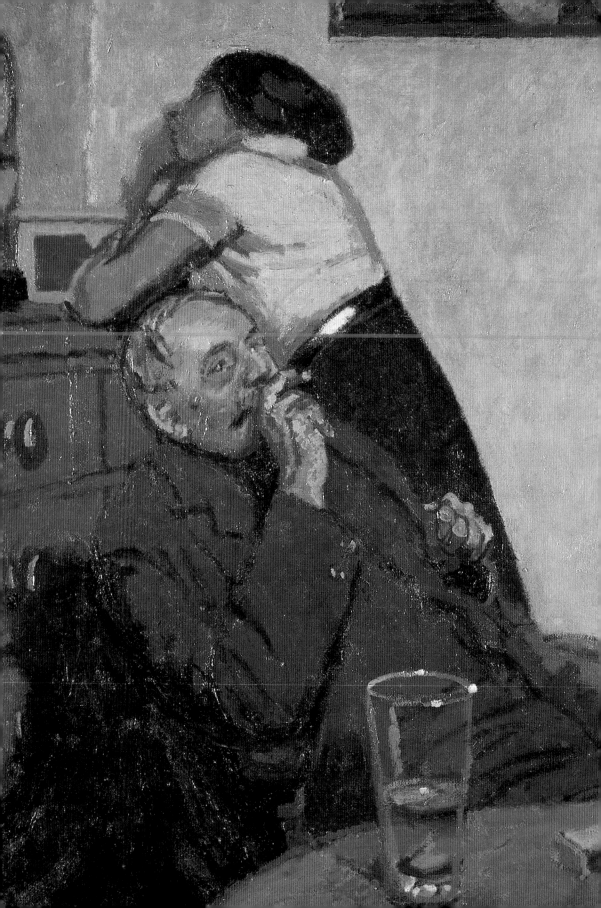

WALTER SICKERT

David Peters Corbett

British Artists

Tate Publishing

Front cover: *Miss Earhart's Arrival* 1932 (fig.51, detail)

Back cover: *Gwen Ffrangçon-Davies as Isabella of France* 1932 (fig.50)

Frontispiece: *Ennui c.*1914 (fig.27, detail)

Published by order of the Tate Trustees by
Tate Gallery Publishing Ltd
Millbank, London SW1P 4RG

© Tate Gallery Publishing Ltd 2001

The moral rights of the author have been asserted

ISBN 1 85437 308 0

A catalogue record for this book is available
from the British Library

Cover design Slatter-Anderson, London

Concept design James Shurmer
Book design Caroline Johnston

Printed in Hong Kong by South Seas
International Press Ltd

Measurements are given in centimetres, height
before width, followed by inches in brackets

CONTENTS

ACKNOWLEDGEMENTS

It is impossible to write on Sickert without relying frequently on the work of his foremost scholars, Wendy Baron, Richard Shone and, in the case of Sickert's graphic works, Aimée Troyen and now Ruth Bromberg, whose catalogue raisonné of the prints appeared as I was revising the book. There is scarcely a page in what follows where I am not indebted to them. The staff of the Islington Libraries were unfailingly courteous and helpful in allowing me access to their Sickert collections, and I am grateful to the librarians at the University of York Library, the British Library and Cambridge University Library for their assistance. David Fraser Jenkins and Jeremy Lewison at the Tate Gallery, and the anonymous reader for Princeton University Press saw the manuscript in draft and made excellent suggestions for its improvement. I was fortunate enough to be a Paul Mellon Fellow at the Yale Center for British Art in 1998. When there I pursued research into Sickert in the most congenial and scholarly of environments. Dick Humphreys asked me to attempt the book in the first place and I at least owe him a debt of gratitude.

INTRODUCTION

In a memoir, Walter Sickert's longstanding friend Osbert Sitwell recalled Sickert coming to dinner soon after the outbreak of the First World War. Sitwell was then Captain of the King's Guard at St James's Palace and the other diners were colleagues of his, 'several rather conventionally-minded young officers'. Sickert (fig.1), 'got on beautifully with them', as he seems to have done with all sorts of people throughout his life. But at one point he 'remarked ... in a voice loud enough for the whole table to hear: "– And no one could be more English than I am – born in Munich in 1860, of pure Danish descent!"'.[1] A provocative thing to say to a group of army officers guarding the monarch at the start of a European war.

It is an amusing anecdote, and it sums up a surprising amount of what one might want to know about Walter Richard Sickert. The combination of charm and the simultaneous baiting of those being charmed is characteristic of Sickert's relationship to audiences all his life. His listeners, at first lulled into a sense that they are secure with what they are being told, are then suddenly confronted with something entirely unexpected and sharply challenging. Sickert always had a knack of exposing the absurdities of received opinion. In this case the effect derives from Sickert's cavalier way with the urgencies of patriotism in a time of warfare, but the material he drew on to startle was, at least by his own mythopoeic standards, accurate enough. Sickert was born where and when he told the officers of the King's Guard he had been, the son and grandson of Danish painters, and had come to Britain to live only at the age of eight as a result of his father's discovery that his sons would be liable for service in the German army. His mother was British, although to confess so would have spoilt the purity of Sickert's joke. The family settled in London and Sickert had a conventional upbringing, culminating in a short career on the stage playing minor roles, under the actor and impresario Sir Henry Irving among others, and a brief attendance at the Slade School of Art in 1881, after which he was taken up by James McNeill Whistler and spirited away to work in the American artist's studio. By the time he came to dinner with Osbert Sitwell in 1914, Sickert was an established figure in English painting, associated with the advanced and challenging in art, on his own account and as an influence on the radical young painters of the modern movement, but also with a reputation as a respected senior artist.

The outlines of his early life, then, accord with his claim for Englishness. But, as was the case with his relationship to the King's Guard, Sickert's attitude to his adoptive country was simultaneously intimate and teasing, the charm always tinged with an ironic distance. Its corollary is what his friend, the French painter Jacques-Emile Blanche, called his 'disdainful discretion, a sort of self-defence, in his attitude towards human contacts – *noli me tangere*'.[2] Sickert is like this in his art, too, changeable, rapid, hard to pin down.

No sooner has he established one style or mode of operation, than he's off, on to something else unexpected. Sickert's career is a record of experimentation which paid little attention to the conventions of either traditional or advanced art.

Throughout his life Sickert's commentators, friends and enemies were all struck by this protean capacity in him, his ability to change his appearance, opinions or style of life apparently at will. It is not a very common gift. Whereas most of us appear entirely subsumed by the character which our lives and status allow us, Sickert seems freer, in a looser relationship to people's expectations, able to indulge and experiment with his own individuality and personality. Nor is this simply an effect of artistic bohemianism, the consequence of a life lived outside the normal routines of social discipline. Bohemians, too, have their rules of behaviour and Sickert was no more respectful of these than of bourgeois requirements for the management of self. He flouted the expectations of the art-world fully as much as those of the establishment. When artists dressed as rebels, Sickert dressed like a gentleman. Once it became fashionable to adopt business suits and ties, Sickert took to loose collars and loud, aristocratic, check suits. When it was a requirement for membership of the circles of advanced art to denigrate the Royal Academy, Sickert praised the high-Victorian academic painter Lord Leighton and became an Associate of the Royal Academy, an ARA; when he was finally accepted there and made up to a full RA, he resigned in less than a year in defence of that perennial symbol of modernist outrage, Jacob Epstein. Sickert is no more easily defined by reference to the supposed freedoms of the artist than he is by any other social criterion.

At the same time, Sickert effected unusual changes to his own identity. At the age of more than sixty he was psychologically able to abandon the use of his first name, Walter, and substitute his middle name Richard, evidence of 'a deep desire to change his identity' according to the art historian Wendy Baron.[3] He frequently altered his physical presentation throughout his life. Beards came and went on his face, transforming his whole appearance, sometimes square cut, sometimes imperial and pointed and sometimes foaming over his collar in luxuriant and patriarchal growth. On occasions throughout his life he shaved his head or otherwise radically altered his hairstyle. 'Few artists ... are more ready to change their names, their beard, and the titles of their pictures,' wrote the *Daily Express* in 1929 at the height of the 'Sickert legend'.[4] This transformative and protean capacity has its counterpart in Sickert's wanderings in London. He often kept two or three studios at the same time and rooms besides, all in different parts of the city, and he moved around the metropolis over the length of his long career from Camden Town to Islington by way of Fitzrovia. He was perpetually fascinated by disguise, by misrecognition, by falsity and by pretence and these fascinations got into the very centre of his art.

A clue to this fluidity and contrariness lies in Sickert's birth and early upbringing. Eight is quite an advanced age to transfer yourself from one culture and one language to another. The marks of that transition perhaps never entirely leave the individual. In Sickert's case, his relationship to the German

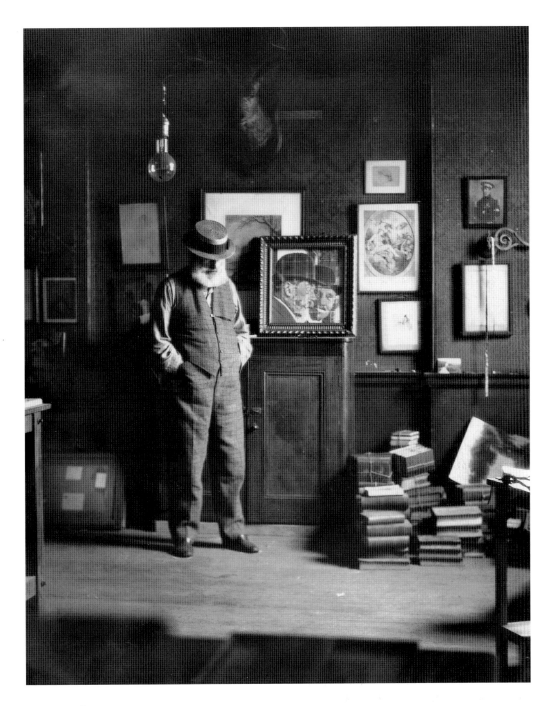

1 Walter Sickert,
c.1918–20, in his studio at
1 Highbury Place
Islington
London Borough of
Islington – Libraries

culture and language of his early youth was never explicit. Sickert visited Munich on his first honeymoon, but then appears never to have gone back. The literature contains virtually no reminiscences of his years in Germany, and he never showed any unusual interest in German art or culture. Instead, he transferred his allegiance and in important ways asserted throughout his life the significance of France; explicitly, against that of his adopted country, England, implicitly, against the German culture of his birth. True, he became a champion of the modern Continental tradition in art, but with very few exceptions that tradition was French. True, he larded his conversation and published writings with foreign words, phrases and sometimes whole sentences, but these too were almost always French, a language in which he was fluent. True, he lived abroad for long periods, but, again, with the exception of some early sojourns in Venice, it was always in France. How far this really constituted a displacement of Germany is open to question, but it is a fundamental instance of the simultaneous difference and intimacy which is the hallmark characteristic of Sickert's life and art. His cultural and physical transference from Germany to England perhaps gave Sickert the emotional distance which never left him, and which allowed his intimate knowledge and love of his second country to be perennially subject to his penetrating and ironic intelligence. The officers of the King's Guard were not the only ones to be teased.

This displacement, geographical, social and psychic from some original moment of integration and homeliness is often seen as a characteristic of the modern citizen. In modern societies, the figure of the emigrant, the wanderer, the dispossessed or the refugee seems to have considerable power to express our sense of deracination and detachment as the world we are born into, continually in flux, remoulds and transforms itself around us. It may be for this reason that Sickert's sense of himself as distant, the observer or watcher whose insight into life is the more acute because he is so little at home in it, exerts such a powerful appeal for us now. His enigmatic qualities, both intimate and mysteriously distant, distil for his audiences their own modern rootlessness and uncertainty.

Sickert knew this aspect of modern life very well. It is, through several transformations, the continuing theme of his art. If his subject matter in his first phase of success as the painter of Camden Town and other grimly modern districts of North London was explicitly that of contemporary life and experience, he also experimented throughout his career with the formal and technical qualities of paint. Sickert is modern both as a technician, preoccupied with form, line and colour, what Virginia Woolf, writing on Sickert's art, called 'the silent kingdom of paint', evolving new solutions to the question of how the painter could represent in new painterly idioms, and as the champion of modern life as explicit subject matter.[5] The mixture of these two ambitions and their mediation through Sickert's always ironic and detached intelligence gives his art its characteristic flavour and makes him a distinctive as well as important modern artist. If, in the end, the technical wins out over Sickert's painting of modern life, he was no less a modern for that.

1

REALISM AND SYMBOLISM

When in 1882 Whistler brought Sickert away from the Slade and into his studio in Tite Street, Chelsea, he introduced the younger artist to an artistic and professional style of great vividness and individuality. Whistler's energy and inventiveness dominated the advanced British art scene. Both as the exponent of a pungently individual art which combined elements of Impressionism and even Pre-Raphaelitism with a personal adaptation of Symbolism, and as a determinedly successful self-publicist, 'his pockets bulging with newspaper articles', Whistler seemed to offer a more persuasive and vital version of modern art than either Lord Leighton, Alma-Tadema and the painters of the Royal Academy or the British realists like George Clausen, Stanhope Forbes and John Lavery.[1]

Sickert's early paintings and graphic works are clearly made under the impact of Whistler's influence. Whistler used an 'alla prima' technique, completing the painting at a single sitting, and selecting and abstracting from the motif in order to do so; his ambition was to produce a unique, definitive representation of the subject rendered in a single view. This desire for instantaneity and speed necessitated a summary representation in which detail and description were subordinated to considerations of unity of tone, colour and design.[2] Sickert's 1884 drypoint, *The Pentonville Road* (fig.2), adopts Whistlerian selection and abstraction to concentrate on a refined and summary description of the scene as a mobile pattern of light and shade. Like his master, Sickert worked directly from life as a graphic artist, adopting Whistler's injunction to concentrate on the central part of the motif first of all and then to work outwards towards the edges of the paper, a procedure which can be clearly seen in a related etching of 1884, *Sixpence Three Farthings, St John's Wood High Street*

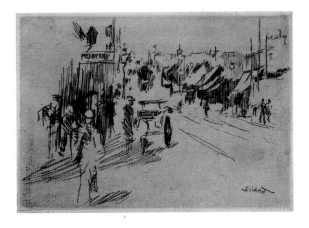

2 *The Pentonville Road* 1884
Drypoint
8 × 11.7 (3 × 4⅝)
Fitzwilliam Museum,
University of
Cambridge

(fig.3). In a different idiom, the oil painting *The Red Shop* (fig.4), executed in a restricted range of tones and, like *Sixpence Three Farthings* or *The Pentonville Road*, concentrating on an anonymous subject in order to emphasise the character of the medium, is typical of the 'pupil of Whistler' as a painter.[3]

In all of these works, the insistence on speed of execution and the consequent subordination of content to an integrity of tone and design, means that the subject matter is represented with a certain imprecision. Whistler exploited this fact by integrating it with an existing symbolist inclination towards the evocation of mystery and indeterminacy in subject. Symbolist in this context refers to what were understood as general qualities of some types of art rather than to a specific artistic movement. The symbolist sensibility was one which sought to evoke the inner meanings of reality by means of association, suggestion and indeterminacy and thus to render 'the invisible by the visible'.[4] Whistler was a leading exponent of this sensibility in his renditions of modern London. His famous series of nocturnes, for example, rework the contemporary in favour of the elaboration of what he called 'poetry' and 'palaces in the night', so that London is remade as mystery and evocation.[5] Sickert learnt from Whistler this evocation of mystery and indeterminacy which was to last, in one form or another, throughout his career and help to shape the enigmatic narrative subjects of many of his works.

The fascination with technique which is so much a characteristic of Sickert's art also seems to have grown partly from this soil, as the art historian Richard Shone has suggested.[6] Whistler's refinement and sophistication in the application of paint and his extreme attention to the role of paint surface and pigment itself in his works proved highly influential on the young Sickert. For the rest of his life Sickert was preoccupied with the technical and executive aspects of painting, an interest which was often productively in tension with the subject matter of his works.

But Whistler's insistence on the subordination of the pupil's art and personality to his own, and the single-mindedness of his artistic egoism could never have held the independently-minded Sickert for very long. Whistler himself helpfully obliged by offering his wayward student the opportunity to broaden his horizons. In 1883 he sent Sickert to France with a parcel and a

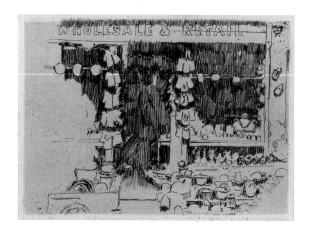

3 *Sixpence Three Farthings, St John's Wood High Street*
1884
Etching
9.9 × 13.8 (4 × 5½)
Fitzwilliam Museum, University of Cambridge

letter of introduction to the painter Edgar Degas. The consequences of Sickert's meetings with Degas in the early 1880s were to be of fundamental importance for the shaping of his career. Degas provided the counterweight to Whistler, and one which was eventually to prove the more significant for Sickert's development.

Sickert later summed up his mature assessment of Whistler by criticising the older artist's alla prima technique, covering 'the whole picture practically in one wet' as Sickert put it, rather than building up a composition through preliminary studies and slow application of paint over earlier, dried, layers. While this gave Whistler the result desired, 'the exquisite oneness that gives his work such rare and beautiful distinction', it was not without costs for Sickert. 'The obligation, or the effort to cover entirely', Sickert went on, 'necessitated an excessive simplification of both subject and background' which 'shows itself in subordinating, in arranging, in digesting any and every complication.' This is Whistler's famous 'harmony' and it is the technique of Sickert's *The Red Shop*, as well as, transposed to another medium, his etchings and drypoints of these years. But harmony for the mature Sickert was too high a price to pay for the over-simplification of the subject, for, he wrote, if Whistler's was an art of simplification and summary, in contrast '*mastery ... is avid of complications*'.[7] It was that complication, managed by an entirely different paint technique, that Sickert found in Degas.

Degas's art was based on the systematic build-up of paint over preparatory drawing, following a preliminary period of sketching and systematic design. It is in essence a traditional oil-paint technique. In this it was the opposite of Whistler's alla prima practice of painting a canvas at one sitting. Moreover, Degas was a leading figure in what is often called 'the painting of modern life', the drive to invent a painting which could deal adequately with the circumstances of the new modernity in nineteenth-century France where, as in Britain, the speed of change and development had become vertiginously fast by the end of the nineteenth century.[8] Degas's subject matter was the everyday, the lives and experience of people in Paris, the metropolitan capital of modernising and industrialising France. He painted café life, the popular

entertainment of the café-concert and intimate domestic moments in bath-room and bedroom, the signifiers of a particularly modern, urban self, curiously isolated and curiously split between the public and private worlds of experience.

Mortimer Menpes, a fellow pupil of Whistler's, remembered that whereas in the early days the pupils 'copied Whistler in every detail', so that 'if we etched a plate we had to etch it exactly on Whistlerian lines', the impact of Degas's subject matter and painstaking preparatory technique led them to experiment outside the ambit of the master's influence. According to Menpes, Sickert brought back from Paris 'enthusiastic descriptions of the ballet girls Digars [sic] was painting'. Initially, this enthusiasm produced only qualified results: 'we tried to combine the methods of Whistler with Digars and the result was low-toned ballet-girls.'[9] But by the time Sickert came to etch *Emily Lyndale as 'Sinbad the Sailor' at Gatti's Arches (Tom Tinsley in the Chair)* (fig.5), towards the end of the 1880s, he had adopted not only Degas's subject matter but also his preparatory drawings and the careful detailing and delineation across the whole surface of the sheet which contrasts with Whistler's summary refinement and centralised compositions. Sickert later wrote of his discovery of Degas and his decision to recast his technique under the French artist's influence that 'the great painters painted from drawings that remained stable, and not in the presence of the "movie" that is nature'.[10] Whistler's concentration on capturing the moment and its mysteriousness had given way to Degas's more balanced relationship between composition and subject matter. Sickert began to imagine a content and meaning different from the rarefied symbolism of Whistler's painting.

Under Degas's influence, Sickert began in the mid-1880s to paint the popular entertainments of modern London, the music halls and acts which, like Emily Lyndale, appeared at halls such as Gatti's Hungerford Palace of Varieties, located near Charing Cross or, like *Minnie Cunningham at the Old Bedford* (fig.6), at some distance from the metropolitan centre, in Camden Town and further afield. Sickert's music-hall compositions, frequently seen in raking perspective across the backs of the audience's heads, echo the compositional devices Degas invented for his café-concert scenes like *The Orchestra Musicians* of 1872 (fig.7). The subject matter of these painting, too, is derived from Degas's café-concerts and ballet scenes, and composition is in the service of the description of subject matter. The

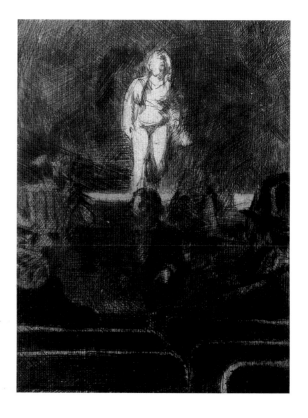

5 *Emily Lyndale as 'Sinbad the Sailor' at Gatti's Arches (Tom Tinsley in the Chair)*
1888
Etching
11.4 × 8.5
(4½ × 3⅜)
Victoria and Albert Museum

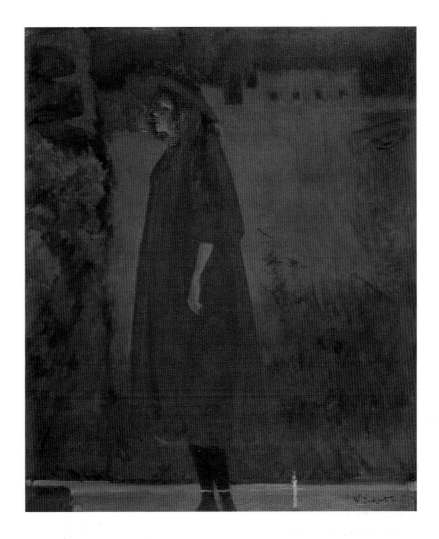

6 *Minnie
Cunningham at the
Old Bedford* 1892
Oil on canvas
76.5 × 63.8
(30⅛ × 25⅛)
Tate

paintings represent the slightly seedy and déclassé world of popular enter-
tainment which was one of the characteristics of modern society in nine-
teenth-century cities that contemporaries most noticed. In painting these
events, Sickert was consciously moving away from the Whistlerian indiffer-
ence to society and towards a painting which directly engaged with the ques-
tion of how best to represent contemporary life and experience.

However important this move from the vagueness and evocativeness of
Whistler's symbolism, the social realism of Sickert's music-hall scenes was
far from absolute. When in 1889 Sickert wrote the introduction to the cata-
logue of an exhibition called the 'London Impressionists', he defined his art
against the apparent realism and preoccupation with the surface appearance
of the visual world then taken to be characteristic of Impressionism. Instead,
drawing his vocabulary directly from Whistler's celebration of the symbolist
aesthetic in his 1885 'Ten O'Clock Lecture', Sickert insisted that 'the most
fruitful course of study lies in a persistent effort to render the magic and
poetry' of London, 'the most wonderful and complex city in the world', and its

inhabitants.[11] Sickert's music-hall scenes draw together the twin strands of his inheritances from Whistler and Degas. The paintings are both about the social realities of London life at the turn of the century and about the transformation of these facts in the work of art so that their inner meanings are revealed in the canvas which embodies them. Like Degas Sickert strives to render the detail of domestic or public social life in the modern age. But that rendition is processed through a language derived from Whistler's symbolism, concerned to evoke through indeterminacy and mystery the hidden 'poetry' which lies beneath the surface of modern experience.

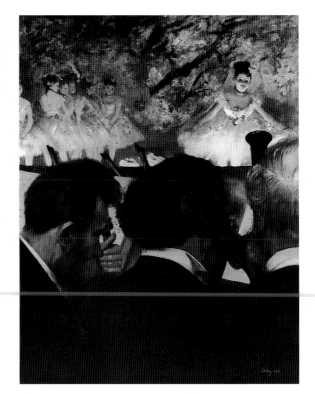

7 Edgar Degas
*The Orchestra
Musicians* 1872
Oil on canvas
69 × 49
(27⅛ × 19¼)
Städtische Galerie,
Städelsches
Kunstinstitut,
Frankfurt

It is possible to see these concerns in the paintings themselves. On first encounter it is the visual complexity of the images which is their most striking characteristic. The first experience of confronting *Vesta Victoria at the Old Bedford* (fig.8), is one of pervasive and fundamental puzzlement. What is depicted here? And what are the relationships between the parts which we can make out? The eye persistently attempts to read the left-hand side of the picture as a hollow space which allows us to see into the hemisphere of the box. But the presence of the audience in the gallery above therefore becomes inexplicable, a problem compounded by Sickert's abstraction and flattening of the vertical divider between the audience and the stage, which here seems flush with the picture plane and parallel to it. Lower down, Sickert offsets the increasing clarity of this vertical element by juxtaposing it with an incoherent passage composed of fields of near-formless colour. It is only when we reach the very bottom of the canvas that the vertical element fully crystallises into the beaded frame of the mirror, at which point the spatial complexities of the painting at last become clear.

In a similar way, *Little Dot Hetherington at the Bedford Music Hall* (fig.9), appears to present the performer directly, offering a slight variation on Degas's typical compositional framing of the stage by the heads of orchestra and audience. It takes a minute to begin to register the problems with this, the triangular forms at the bottom of the canvas, the truncation of the audience, and the odd passage at the extreme left side of the stage; and a minute more before we begin to see that the stage, the performer and the audience are all reflected in a large mirror, while the triangular elements are the final, empty row of chairs at the back of the hall. *The P. S. Wings in the O. P. Mirror* (fig.10), varies Degas's formula by placing the heads of the watching audience in front of the 'Off Prompt' mirror, while the mirror itself reflects the 'Prompt Side' of the

8 *Vesta Victoria at the
Old Bedford* c.1890
Oil on canvas
36.8 × 23.5
(14½ × 9¼)
Private collection

stage where the singer appears to be performing disengaged from her spectators. *The Sisters Lloyd* (*c.*1888–9, Government Art Collection), offers a further variation, this time substituting for the illusion of the mirror the equally striking illusion of the painted drop curtain which adds a completely fictional depth and articulation to the scene on the stage. Sickert, in short, assembles contrasts of represented space and flatness of picture surface in order to confuse and problematise our perceptions of the events he depicts.

By complicating perception for us in this way *within* his paintings, Sickert gestures towards the complexities of perception *outside* them. Sickert's music-hall paintings offer us metaphors for the difficulty of understanding modern life simply by attending to the 'realism' of its surface appearance. He asserts, in contrast, the virtues of a deeper analysis, such as symbolism claimed to provide, one which would penetrate below the deceptive surfaces of the world and reveal its true 'poetry and magic'. The theatricality, the literal falsity and preoccupation with appearance over deeper truth which the music-hall embodies makes it an ideal metaphor for this process. 'Poetry and magic' arise not only from the dissembling glamour of the halls, but from the gap between reality and surface appearance, the act of looking and the truth of what is seen, all played out, literally, on the stage where the essences of modern experience are given expression in the surface of modern entertainment.

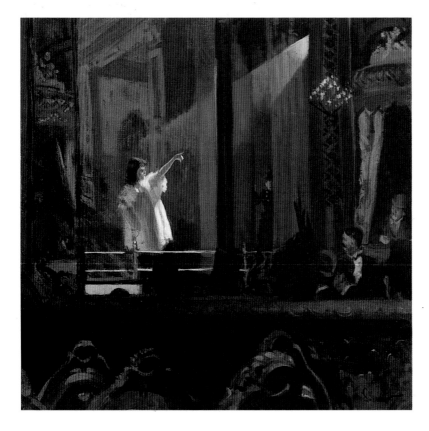

9 *Little Dot
Hetherington at the
Bedford Music Hall*
1888–9
Oil on canvas
61 × 61 (24 × 24)
Private collection

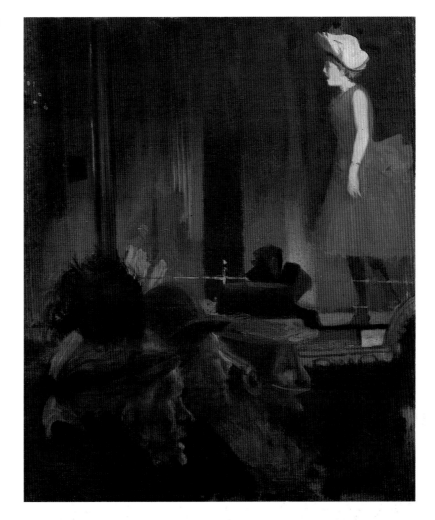

10 *The P. S. Wings in the O. P. Mirror*
c.1889
Oil on canvas
61 × 51 (24 × 20⅛)
Musée des Beaux-
Arts, Rouen

Sickert in these years was beginning to get a reputation, and his early critics quickly noticed this combination of realism and symbolism in his work. As a result, reviewers frequently saw Sickert's painting as a very modern kind of puzzle, identifying a very great technical ability put at the service of what seemed unequivocally sordid and ugly subject matter. On the one hand, for the critics Sickert was the proponent of an 'extremist Realism', a recorder of the surface of the world, whose 'eye is a purely mechanical contrivance for conveying images' which 'seems to strip subjects of all the[ir] aura'; on the other, he is a painter who, like the symbolist poet Mallarmé, 'gives you a fragment here and a fragment there, enough to prove the reality of his vision, but not enough to render it visible to the world', or who shows 'how ... a subject may be beautified by the touch of mystery that results from a dextrous suggestion of the unseen'.[12] The critics understood that Sickert had a visual project, sustained over a number of years and a great many works, but they also found it quixotic and hard to comprehend. In fact, Sickert's policy of collapsing apparently opposed aesthetic strategies into a single endeavour in this way is

19

fundamental to his version of what a 'painting of modern life' in Britain might be at the turn of the nineteenth century. He proposes an art which is concerned both with the deep analysis of symbolism and the surface appearance of the world. For him, it is only by this combination that the 'mystery' and meaning of the surface of modern life can be adequately identified and represented.

We should see Sickert, then, as heir to both the realist and symbolist strands of painting in Britain, interweaving both in his art in the service of a new vision of modern life. We can see what this means by comparing one of Sickert's works, clearly derived in part from Degas's example, to a work by the older artist. Degas's 'Waiting' is one of a series of brothel scenes he made in the 1870s (fig.11). It may be contrasted with Sickert's *Two Women on a Sofa – Le Tose* (fig.12). Sickert's picture has its place in the Venetian series of paintings which I shall discuss later in this chapter; it is intimate, domestic and slightly dingy in feel despite the brilliance of the colour. But, whereas Degas's scene is straightforwardly narrative, giving us all the visual clues we need to allow us to build up a story around it, to place it in a sequence of events; we do, after all, know what these women are waiting for; Sickert's *Le Tose* is mysterious. The subject of these women's conversation, the nature of their relationship, hinted at in the slightest physical proximity and difference, is opaque to us. We will never be able to work it out from the clues the picture offers us. The emphasis in the Sickert is really on this sense of mystery and unknowability. This is what Sickert's friend Jacques-Emile Blanche meant when he noted Sickert's ability 'to suggest situations guessed at rather than seen', and observed that 'all relations with Sickert have an extraordinary, a mysterious character'.[13] We see events occurring but we have no means, on the basis of a surface description of their happening at least, to tell what they imply or what they are truly about. In qualifying his realism and immediacy, the insistent contemporaneity of his subject matter and models, with this sense of mystery and indeterminacy, I believe Sickert is drawing on his symbolist heritage. As with the music-hall scenes, we cannot tell from the surface realities of the world what it truly means, and Sickert's paintings present us with opaque and indeterminate subjects as a sign of that fact. If we are to grasp the truths of modern life, claim Sickert's works in these years, we have to look below the surface, to intuit the currents of experience and understanding that lie beneath.

When he moved from London to Dieppe in 1898 for a stay of seven years, Sickert

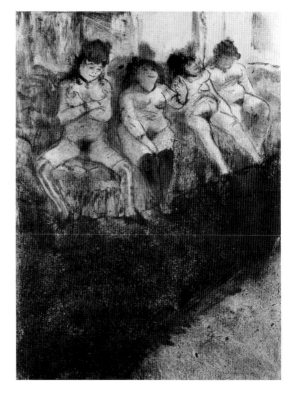

11 Edgar Degas
Waiting c.1876–7
Monotype
21.1 × 16.4
(8¼ × 6½)
Musée Picasso, Paris

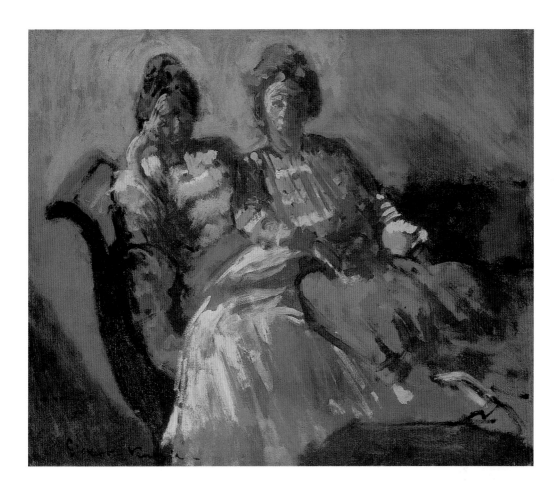

12 *Two Women on a Sofa – Le Tose*
c.1903–4
Oil on canvas
45.7 × 53.3
(18 × 21)
Tate

brought these preoccupations with him. Sickert had married his first wife, Ellen Cobden, in 1885, but by the end of the 1890s the marriage had come to an end and the couple separated. Faced with the collapse of his relationship and his own shallow toehold in the London art world, Sickert seems to have decided to make a radical move. At the time, Dieppe was an established English colony, midway between London and Paris and with a vigorous artistic and social life. Much of the work he produced in Dieppe over the subsequent years, as well as during the shorter stays in Venice, initially in 1895 and then regularly interspersed throughout his Dieppe period from 1900 to 1904, perpetuates his interest in describing the visual surface of appearance in a way which interwove the evocation of mystery Sickert had learnt from Whistler and his symbolist influences. *The Statue of Duquesne, Dieppe* (fig.13), sets the statue against the light and confers on this ordinary corner of an ordinary square a brief otherworldliness reminiscent of the Thames scenes Whistler had made in the 1870s. The looming presence of *St Mark's Venice (Pax Tibi Marce Evangelista Meus)* (fig.14), or even the façade of St Jacques in *Dieppe, Study No.2* (fig.15), have an insistence on the sheer physical presence of the buildings that seems to assert significance. Sickert concentrates on motifs which, like Whistler's shopfronts and misty views, appear significant without

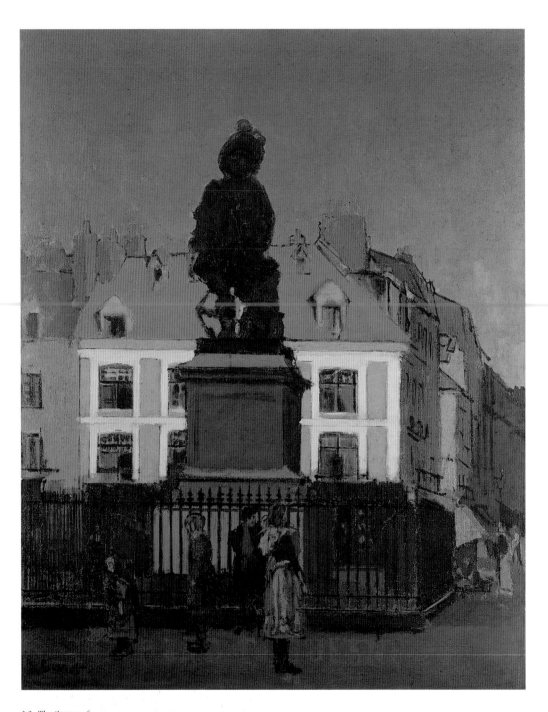

13 *The Statue of
Duquesne, Dieppe*
1902
Oil on canvas
131.6 × 104.8
(51¾ × 41¼)
Manchester City Art
Galleries

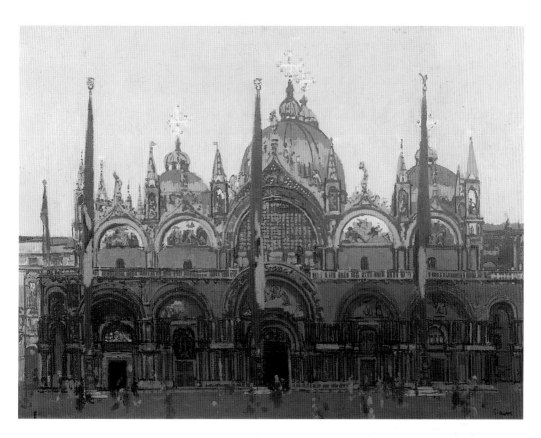

14 *St Mark's Venice
(Pax Tibi Marce
Evangelista Meus)*
1895–6
Oil on canvas
90.8 × 120
(35¾ × 47¼)
Tate

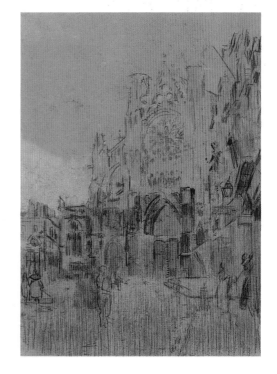

15 *Dieppe, Study
No.2: Façade of St
Jacques c.*1899
Chalk and wash on
paper
32.1 × 23.2
(12⅝ × 9⅛)
Tate

the viewer being able to say in what their significance consists. Unlike Whistler's example, however, Sickert now chooses in the main to paint buildings of importance in their own right, but often places them in everyday contexts, reinserted into the street and conjuring up the contrast between the world of everydayness and the magnificence and assertive claim for importance that these towering buildings carry with them, and with which they bear down on the observer. The result is a peculiar tension, a conversation between the significant, the spiritual or the mysterious and the commonplace which defines these works' power. *Pax Tibi* is almost Byzantine in the resistence of its distant magnificence to the bustling figures pursuing their normal concerns at its foot, so that a contemporary critic thought that it 'reveals a singularly pure quality of poetry'.[14] Wendy Baron was right to quote, in a discussion of this painting, the following comments Sickert made in 1923 repudiating Impressionist aesthetics:

> The theory that it is the main business of an artist to paint half a dozen views of one object in different lights cannot be seriously maintained [Sickert is probably thinking of Monet's great series of paintings of haystacks or the façade of Rouen Cathedral]. It would be nearer the truth to say that the artist existed to disentangle from nature the illumination that brings out most clearly the character of each scene.[15]

That final statement, 'that brings out most clearly the character of each scene' sums up the symbolist aspects of Sickert's art. It is a question of refining nature, the surface appearance of the world, in order to reveal the essence which will illuminate the real 'character' of the motif. Like the music-hall scenes, the paintings Sickert made in Dieppe are images of modern life and experience. But their success in this consists not simply in the rendering of surface appearance. It is located most powerfully in the mysteriousness and indeterminacy of Sickert's rendition, which brings his ambition to describe the interior 'magic and poetry' of reality most fully to life.

These qualities are visible as well in the series of interiors Sickert painted in Venice to which *Two Women on a Sofa – Le Tose* belongs (fig.12). *Conversations* (fig.16), not only demonstrates the variations Sickert developed, using nude and clothed models to explore the psychological tensions inherent in the close proximity of two people within a confined interior, it is also conceived as

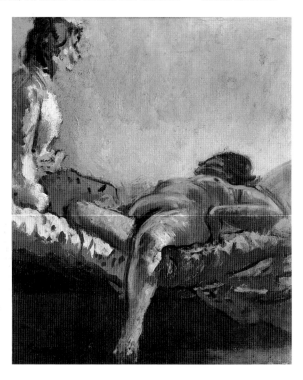

16 *Conversations*
1903–4
Oil on canvas
36.8 × 44.5
(14½ × 17½)
Private collection

an exploration of that intimate but contested space. Paintings like these are the obverse of Sickert's images of public spaces, whether the swarming galleries of the London and Paris music-halls or the more arid and apparently less crowded spaces he describes in front of St Mark's, Venice, or the open squares of Dieppe and its seafront. Now he looks within, to the ways in which the same themes of alienation, anonymity and the complexities inherent in representing or thinking about the self find their expression in more private places. This is a theme Sickert was to return to in the interiors he began to paint after he tired of his 'isolation in Dieppe' and moved back to London in 1905.[16]

While he was in Venice, Sickert also produced the first of his paintings which deal with a more traditional theme, the dissolution of old age and the image of death it expresses. It was a subject he returned to in his own long old age, but in 1903 and 1904 he seems content to observe the disintegration of the body, as in *Mamma mia Poveretta*, (fig.17) and a companion piece with the same date and title. Like the tense intimacies and mysteries of the interior conversation pieces these works concentrate on the ways in which experience weighs upon the self. The critics found the image deeply shocking with its 'over-stated ugliness' and 'old blear-eyed face'.[17] But this dissolution, placed next to a continued insistence on the self against the invasions of old age and death, are the necessary contrasts to Sickert's other subjects. Experience and the pressure of experience on the unknowable and mysterious self, this is the theme of all his investigations into modern life.

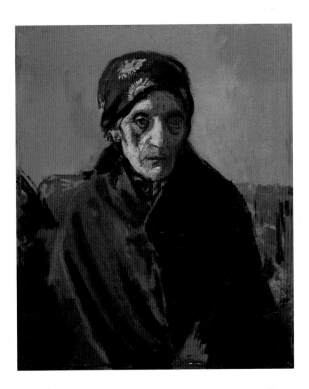

17 *Mamma mia Poveretta* 1903–4
Oil on canvas
46.1 × 38.2
(18⅛ × 15)
Manchester City Art Galleries

2

THE PAINTER OF MODERN LIFE

In 1905 Sickert returned to London and took lodgings at 6 Mornington Crescent, Camden Town. This predominantly working-class area of North London had originally been built to house the servants and tradesmen who serviced the aristocratic houses around Regent's Park. But in the nineteenth century Camden Town had been split by the new railway lines running towards St Pancras, Euston and King's Cross Stations, so that by the time Sickert moved in it was a dingy and unfashionable district of grim terraces and bed-sitting rooms.[1] This suited Sickert very well. He said he loved London 'for its evil racy little faces [and] the whiff of leather and stout from the swing doors of the pubs', and Camden Town encapsulated this brutal quality in modern urban life.[2] It is this renewed urge towards an insistent realism that appears in the paintings Sickert began to make in London. They take up the music-hall themes he had explored earlier and develop the paintings of couples in bedroom interiors he had made in Venice. In the process Sickert, 'the Master of North London', created a series of works which advanced the ambition of contemporary artists to invent a painting which would do justice to modern life.[3]

When Sickert returned to the subject of the music halls in 1906, he concentrated not on Degasesque action on the stage framed by the watching audience, but on the audience itself. *The Old Bedford* (fig.18), like *Noctes Ambrosianae* (fig.19), features the crowd of watchers who filled the halls, staring, gawping or peering down, transfixed by the invisible action which is taking place on the stage below. *Théâtre de Montmartre* (fig.20) underlies the imagined intensity of the audience's emotions with intense colour and a powerful insistence on the physical materiality of the paint. Saturated with the violent reds of the background, this group of watchers shifts uneasily between fascination and, in the figures to centre right, a looser, more relaxed sociability. Sickert's interest is in the audience itself, and the meaning of the audience for him seems to have revolved around the subject of looking, the act of observation and comprehension which these observers conjure up. These louche, shabby figures are transported by the tinselly brilliance of the performance into a world of intense visual engagement which seems entirely foreign to their everyday lives. In the obituary Sickert wrote of Spencer Gore after the early death of his friend and fellow painter in 1914, Sickert described Gore's ability to evoke the 'beautiful' out of the most uncompromisingly 'modern' of materials. For Gore:

> a scene, the dreariness and hopelessness of which would strike terror
> into most of us, was for him matter for lyrical and exhilarated
> improvisation. I have a picture by him of a place that looks like Hell,

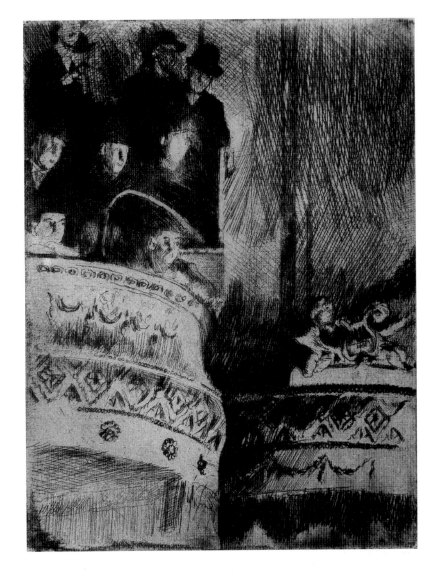

18 *The Old Bedford*
1906
Etching
11.1 × 8.6
(4⅜ × 3⅜)
The British Museum

with a distant iron bridge in the middle distance, and a bad classic
façade like the façade of a kinema, and two new municipal trees like
brooms, and the stiff curve of a new pavement in front, on which
stalks and looms a lout in a lounge suit. The artist is he who can take a
piece of flint and wring out of it drops of attar of roses.[4]

This is a claim about the capacity of art to transform the grimy circumstances
of life. But more specifically it is also a claim about the act that is most char-
acteristic of the visual arts, the act of looking itself, a theme Sickert had
broached already in the visual complexities of his first series of music-hall
scenes. It is the visual itself which carries the possibility of understanding and
which can position the horrors of modern urban life in a meaningful order
through its aestheticising gaze. Sometime around 1906 or 1907 Sickert
explored this further in *The Studio: The Painting of a Nude* (fig.21), in which the

nude model, passive, almost defeated in her stance, is placed at the centre of a web of looks and reflections which extend outwards towards the viewer. The object of study is passive here, while the active gaze of the painter, multiplied threefold by the reappearance of Sickert's mirrors and powerfully imaged in the foregrounded hand and brush, controls and defines, seeing and comprehending everything set out before it.

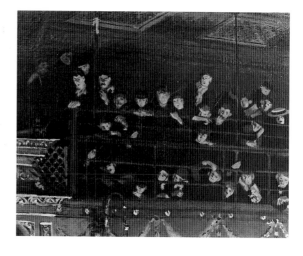

The sense of these works seems to be that the painter can see and understand the multiple complexities and opacities of modern life. By virtue of his distance, the calm, dispassionate gaze of the painter sweeping across the realities of contemporary existence and registering them in the confident and controlled surfaces of his painting, the painter can assert his credentials for the observation of reality. Sickert's dispassionate view of the realities of English and French life, his ability to identify intimately with them and yet to understand them as if he stood outside, comes strongly into play. Sickert is among the audience. Like the figures in *Théâtre de Montmartre*, he, too, takes part in the action going on before him; but he is also the observer par excellence, able to stand back and analyse what he has seen and the medium through which he sees it.

In saying this about Sickert 'the dispassionate observer' I am agreeing with

19 *Noctes Ambrosianae* 1906
Oil on canvas
63.5 × 76.2
(25 × 30)
Nottingham City Museums and Galleries, Castle Museum & Art Gallery

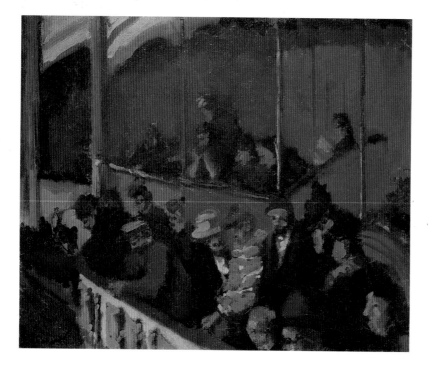

20 *Théâtre de Montmartre* 1906
Oil on canvas
48.9 × 61
(19¼ × 24)
By kind permission of the Provost and Fellows of King's College, Cambridge

Richard Shone, whose phrase this is.[5] Where I think Shone does not go far enough is in failing to perceive that this position is ultimately one Sickert longs for rather than lives. It is self-serving, placing him in a position of authority and power, asserting his control through the wielding of the brush, and confirming what was perhaps a temperamental inclination towards distance and observation. But by painting and etching work which defines the painter as the authoritative observer of modern experience, life becomes something which happens to other people. Sickert places himself outside the difficulties and anxieties of that experience, which he can, therefore, observe and master. As a critic noted in 1912, 'Mr Sickert has the air of an eavesdropper peering through the keyhole, he catches his victims unaware' and so can feel superior to them.[6] He releases himself from the pressure of modern life, gives himself an escape route and makes a powerful and appealing claim for painting, indeed for art itself, at the same time. But the fact is that this claim is as much part of the anxiety and pressure as what it observes. It is a fiction. Sickert's observation is in fact anything but dispassionate. On the contrary, it is of vital importance to him to assert his dispassionateness, his status purely as observer, because he is so deeply and intimately caught up in the action going on.

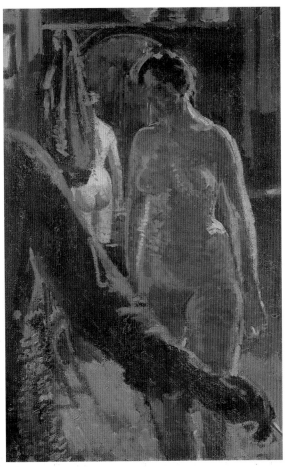

21 *The Studio: The Painting of a Nude* c.1906–7
Oil on canvas
75 × 49.5
(29½ × 19½)
Private collection, courtesy of Sotheby's

We can see Sickert's deep involvement in defining this role for himself in the London work of these years, which, following Wendy Baron, might be called the Camden Town period, running from 1905 to 1914.[7] In the paintings he produced during this part of his career, Sickert took the dingy streets and interiors of Camden Town for his subject matter and evolved a series of works that place him as the detached and authoritative observer of the contemporary scene, within it but not of it. *La Hollandaise* (fig.22), a characteristic work of the time, shows a middle-aged nude on a bed in a shabby domestic interior. The art historian Anna Gruetzner Robins has discussed the way Sickert's choice of female models at this period favoured those whose bodies were not easily idealised. He selected models who were middle-aged and whose bodies were fleshy because their ordinariness could serve he believed as a metaphor for authentic, truthful social observation, alert to the brutal realities of experience.[8] The disregard for conventionally attractive models, presented in a titillating or erotic way in bedroom interiors, Sickert's insistence on the actuality of the women's bodies with their thickening waistlines and pendulous breasts, is a means of strongly asserting the reality of what is shown. This, Sickert seems to be saying, is how life actually is: I can show it to you in all its reality. The more thoroughgoing the ordinariness of the subject, the more powerful the claim to represent 'reality' would seem to be.

Sickert advanced this argument when, in May 1910, he published a short article on 'Idealism' in *The Art News*. In the essay he set himself against the idealisation of the world in contemporary painting and recommended an alternative. Sickert's prime target was the highly stylised and flattering portrait images created by John Singer Sargent and those who imitated him, what Sickert called elsewhere 'wriggle-and-chiffon' (fig.23).[9] For Sickert it was an absurdity that Sargent's work should be regarded 'as the standard in art, the *ne plus ultra* and high-water mark of modernity', when it was in reality a form of flattery in which the sitters were beautified and rendered as glamorised and ideal versions, not of what they were, but of what they would have liked to be.[10]

In 'Idealism' Sickert's argument is that any 'ideal work' such as this is compromised by its ultimate reliance on the inventiveness of the individual painter. In contrast, the artist whose 'taste' is sufficiently coarse to prepare him to take 'the whole field of nature' for his subject can engage with wider and more meaningful realities. This is an argument for painting as implicated in the experience of life. Art cannot be defined by what is 'nice' – the English sin according to Sickert – nor by the limits of the autonomous self. It can only function properly when it accepts its own constitution as a material practice and seeks to encapsulate the world it observes in the 'gross material facts of bulk and shape, and colour'. For 'such are the conditions of the very existence of plastic art'. Art like Sargent's which is tasteful – 'nice' – abrogates its potential for the identification of 'observations, and conclusions, that are very serious realities to us':

> The more art is serious, the more will it tend to avoid the drawing-
> room and stick to the kitchen. The plastic arts are gross arts, dealing

22 *La Hollandaise*
c.1906
Oil on canvas
51.1 × 40.6
(20⅛ × 16)
Tate

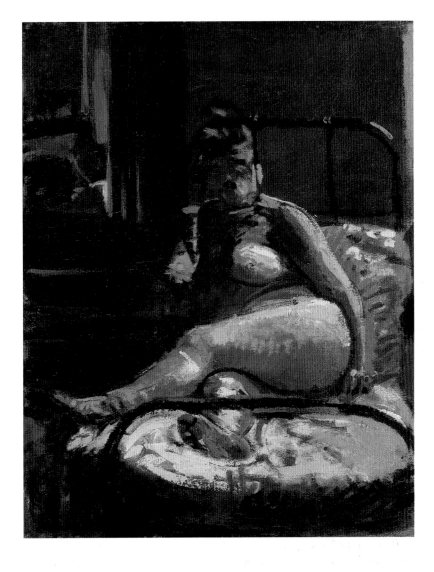

23 John Singer
Sargent
The Misses Hunter
1902
Oil on canvas
229.2 × 229.9
(90¼ × 90½)
Tate

joyously with gross material facts. They call, in their servants, for a robust stomach and a great power of endurance, and while they will flourish in the scullery, or on the dunghill, they fade at a breath from the drawing-room.[11]

Later in the same year Sickert elaborated on what 'the scullery, or ... the dunghill' might mean by reflecting on the inadequacy of portraiture of this type to capture anything but a false, belittled, version of the individual. He imagines the transformation of an ordinary woman – whom he calls Tilly Pullen, an everywoman of the lower classes – into the idealised subject of a modern drawing-room portrait. In that fictional and meretricious context, he says, she cannot be interesting:

> But now let us strip Tilly Pullen of her lendings and tell her to put her own things on again. Let her leave the studio and climb the first dirty little staircase in the first shabby little house. Tilly Pullen becomes interesting at once. She is in surroundings that mean something. She becomes stuff for a picture. Follow her into the kitchen, or, better still ... into her bedroom; and now Tilly Pullen is ... become a Degas or a Renoir, and stuff for the draughtsman.[12]

Sickert's 'gross material facts', then, are the instruments through which a reconstitution of painting will be effected, abolishing the effete and genteel language of commercial portraiture for a roughly authentic account of the intimacies and privacies of contemporary life. This is a characteristically modern ambition, and in the paintings executed during the years between 1905 and 1914 these subjects become a diagnosis, an anatomy of modern life which Sickert had argued for as painting's role in the 'Idealism' essay. The lassitude and boredom of the city are distilled into succinct images of the everyday, the 'serious realities' and material 'facts' of contemporary existence in the first decades of the twentieth century. They address the question of how one could paint the experience of modern life in such a way as to carry conviction and the possibility of real understanding. Sickert's answer was to widen the themes of art. 'Anything!' he wrote, 'this is the subject matter of modern art'.[13]

Using favourite models like the reformed alcoholic and jail-bird known as Hubby, and his female counterpart, Marie who was often paired with him in compositions, Sickert refined and explored this vision of modern life as urban squalor, suppressed physical or emotional violence, and domestic truth. *Off to the Pub* (fig.24), features the two of them impersonating some minor drama of the hearth which is almost risible in its inconsequence and abnegation of the heroic. *Sunday Afternoon* (fig.25), shows them in the midst of a wordless but significant emotional exchange. *Woman Washing her Hair* (1906, Tate Gallery), records the elemental efforts of care the body demands, allowing the painter, like Degas before him, to insinuate himself in the most intimate and hence most authentic-seeming moments of contemporary existence. *Girl at a Window (Little Rachel)* (fig.26), shows 'a little Jewish girl with red hair', as Sickert recalled, the daughter of his frame-maker, shyly looking out onto the

24 *Off to the Pub*
c.1912
Oil on canvas
50.8 × 40.6
(20 × 16)
Tate

Below left
25 *Sunday Afternoon*
c.1912–13
Oil on canvas
50.8 × 30.5
(20 × 12)
The Beaverbrook
Foundation,
Beaverbrook Art
Gallery,
Frederickton, N. B.,
Canada

Below right
26 *Girl at a Window
(Little Rachel)* 1907
Oil on canvas
50.8 × 40.6
(20 × 16)
Tate

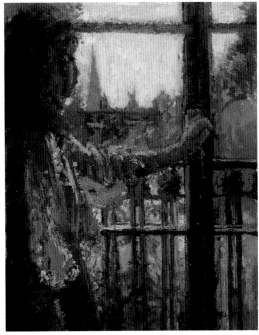

colours of the modern world, in fact out of Sickert's studio in Mornington Crescent, Camden Town.[14] These lives are the essence of modern experience: their basic quality, the sense of existence reduced to only the most elemental of vital activities and experiences, allows them to embody the modern age in their authenticity and faithfulness to fundamental patterns of experience. Sickert claimed that, as a painter, he could observe and comprehend that life, communicating it in the fluent and brilliant summations of his paintings to an expectant audience.

The best known of the paintings of this period is *Ennui* (fig.27), a work which exists in a number of versions. Once we look beyond the placid contentment of the central figure (Hubby once again) in the version belonging to the Tate Gallery, and notice the utter dejection and boredom of Marie miming the woman slumped at the rear of the room, every detail of the environment metamorphoses from its familiar banality and becomes disagreeable and disturbing. As an indication of this Sickert exploits the distortion perspective enforces towards the edge of a canvas by positioning the vertiginous, looming beer-glass (in fact the correct size for the perspective) to unsettling effect. It is Sickert's capacity to encapsulate stark horror in the banal and the familiar which defines much of his work at this period, relentlessly bearing down on the suburban horrors of alienation and unhappiness dramatised in an ordinary sitting room.

The true culmination of this period of Sickert's career, however, is the so-called Camden Town Murder series. The victim, a prostitute named Emily Dimmock, was brutally killed in Camden Town in September 1907. The murder gave rise to a widely reported trial and the sensational acquittal of the accused in the same year. Sickert's relationship to this material is complex. There is a large number of drawings, etchings and paintings made in 1908–9 to which Sickert at one time or another attached the title. Wendy Baron is probably correct to ascribe this association to Sickert's 'flair for publicity' which made the murder 'an umbrella to encompass several independent series'.[15] The pungent details of working-class life in Camden Town given by witnesses at the trial, what the *Observer* newspaper summed up as 'the utter depravity of a particularly unsavoury phase of life', and the thoroughly unpleasant subject matter must have appealed to Sickert, engrossed as he was in his project to present modern life to his audience through the medium of its most disquieting manifestations.[16]

Sickert's major decision during his Camden Town period was to call on the Venetian conversation pieces he had made during 1903–4 and develop further the psychological interest which the juxtaposition of a naked figure and a clothed companion immediately sets going in the spectator's mind. The four key paintings of the series all exploit the possibilities of such a juxtaposition. *Summer Afternoon* (c.1908, Kirkcaldy Museum and Art Gallery), and *The Camden Town Murder* (fig.28), offer this pairing as the slightly mysterious scene of intense but inexplicit interaction between couples. The effect is highly generalised. These are not illustrations of the murder story. There are no unequivocal bodies depicted here, no blood and no weapons, physical violence is absent. The male figure in *The Camden Town Murder* may be depressed because he has

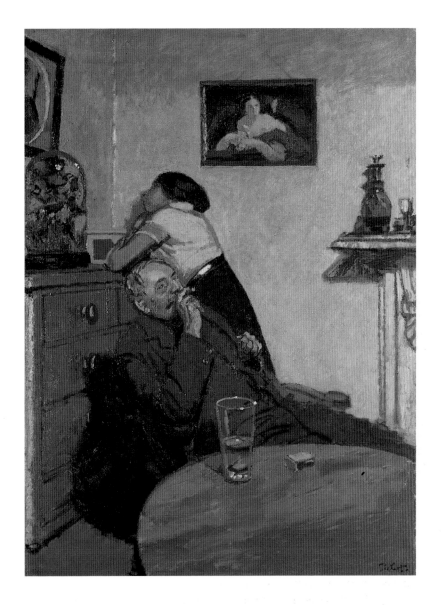

27 *Ennui c.*1914
Oil on canvas
152.4 × 112.4
(60 × 44¼)
Tate

murdered his companion, but he may just as convincingly be worrying about the pair's finances or future prospects in the job market. But in the slightly later *L'Affaire de Camden Town* (fig.29), and *Dawn, Camden Town* (fig.30), Sickert begins to develop changes. In the case of *L'Affaire*, Sickert produces a shocking image of the naked woman, apparently cowering away from her male partner. This is the one painting in which the threat of physical violence and the reality of psychic violence seem most nearly to crystallise. As Anna Gruetzner Robins explains, 'it was Sickert's ambition' in these works, 'to test the notion of the academic nude' so that they 'defy all conventional notions about' the nude and its 'purity'.[17] The exposure of the woman's body is so emphatic and, for its time, so explicit, that the possibility of sexual violence or exploitation becomes unavoidable. In *Dawn, Camden Town*, the power relations

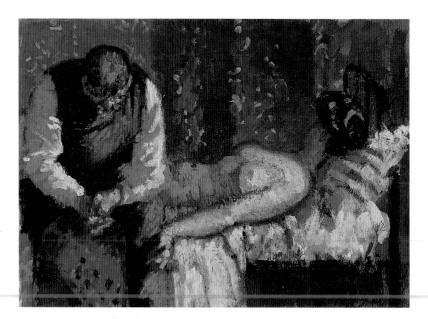

28 *The Camden Town Murder* c.1908–9
Oil on canvas
25.6 × 35.6
(10⅛ × 14)
Yale Center for British Art, Paul Mellon Fund

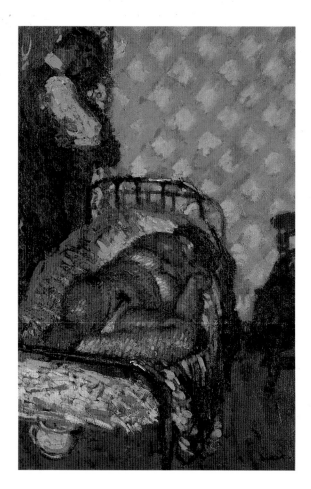

29 *L'Affaire de Camden Town* 1909
Oil on canvas
61 × 40.6 (24 × 16)
Private collection

of the pair seem partly reversed. Sickert here offers the woman as dominant, an implication which also seems to occur in *Summer Afternoon*. If sexual violence is a theme of these paintings, then its necessarily corollary seems to be sexual fear, that men unable or unwilling to engage the relationship are provoked into violence by their own inadequacy.

Taken at this level, Sickert's dispassionate investigation of the circumstances of pared-down lives, his fascination with the mundanities of the world are important examples of the ambition of artists to create a representation of modern experience, to define and communicate the modern world on the surface of their canvases. And yet, at the same time, these paintings are instances of Sickert's famous abjuring of the subject, his indifference or active neglect of the motif in favour of painting which is concerned only with itself, with surface, technique, paint as material artefact. This is Woolf's 'silent kingdom of paint', the relationship of tone, colour and line across the surface of a flat canvas. The Camden Town Murder paintings are famous for their cavalier attitude to subject matter. Perhaps as a result of his 'flair for publicity', Sickert retitled his works with abandon. The picture now usually known as *Dawn, Camden Town* (fig. 30), was exhibited at different times as *Summer in Naples* and *Dawn. The Camden Town Murder* (fig. 28), is also *What Shall We Do For The Rent?*, and the painting exhibited as *The Camden Town Murder Series No.1* became *Summer Afternoon* and, again, *What Shall We Do For The Rent?* On another occasion, *Sunday Afternoon* (fig.25), which I have presented as a double portrait in psychological tension, was referred to by its creator as *My Word, These Onions Don't 'Arf Repeat*.[18] This freedom to name and withdraw names has been taken as a signal of disdain for subject matter. Sickert teases any members of his audience inclined to take the narrative too seriously. In the end, Sickert believes in the integrity of the visual character of his paintings so strongly that titles become irrelevant. Switching from *The Camden Town Murder* to *What Shall We Do For The Rent?* becomes a way of pointing up the fact that the painting as a visual object changes not at all with these changes of title. The extraordinarily dense and declarative paint-work in a number of these works, particularly *Dawn, Camden Town* and *Summer Afternoon*, might be taken to reinforce this interpretation. His first biographer, Robert Emmons, thought Sickert's works had no passion, 'unless it be the pure passion of paint. The chief drama of his pictured world is the drama of light and shade'.[19] For Emmons, Sickert's emphasis is on the paint not on the subject.

It is often said that 'modernism' as a type of painting is marked by precisely this indifference to the subjects of the world and engagement instead with a 'pure painting', preoccupied with its own extension as pigment over the face of the canvas. The influential modernist critic Roger Fry in later years tried to make Sickert over into an exemplum of a particular version of this 'modernism, 'significant form'. Fry made Sickert out to be a modernist pure painter, an exponent of the 'silent kingdom', or rather he tried to. Fry's close friend, Virginia Woolf resisted this in the celebrated essay on Sickert, published in 1934 from which this quotation comes. Woolf, consciously setting herself against the views of her friend, suggested we might see Sickert as the painter of novelistic event and story who 'likes to set his characters in motion,

to watch them in action'.[20] He emerges from her description as preoccupied not with paint so much as with visual narrative, the exigencies of story-telling in a medium without words. It is disconcerting to see how fully this approach suits Sickert: subject and anecdote emerge persuasively from Woolf's impassioned, intellectual, analysis as central characteristics of Sickert's art.

But the fact is that Sickert fits into neither of these categories. To make him into a 'modernist' of the 'pure painting' variety is to neglect his investigation of important but non-traditional modern subjects; to claim him for the 'painting of modern life' is to downplay his indifference to subject when it competes with the action of paint itself. Sickert was flexible enough to get on well with Fry and his Bloomsbury Group associates, but he never fell easily into the 'significant form' category, and Woolf's insistence on narrative and anecdote, brilliantly illuminating though it is in some ways, is partial and myopic at just the moment when Sickert's art actually comes alive as painting. We need to understand Sickert's work as *sui generis*, unsuited to the competing claims of either subject or pure painting. Sickert's modernity as a painter lies in this ambivalence and unresolved quality. His art is modern because it is concerned with the material quality of paint itself, but Sickert cannot believe that there is anything logical in taking the further step of some 'modernist' art and abjuring subject matter altogether. His choice of motifs is calculated, not simply intended to alarm the bourgeoisie. It is evidence of a real commitment to seeing and understanding modern life.

It will help to clarify what this means if we return to *La Hollandaise* (fig.22). The 'sordid', aggressive quality of the motif I have already discussed in the painting, is partnered by the aggression of the paint-work, wiping off the face of the model and substituting a leonine or mutilated surface which is in fact the visual tracking of the paint itself, pushing away identity in favour of a declaration of the material strokes of paint. But instead of resting contentedly with the domination of paint over the subject, Sickert makes the implications of that assertion the keystone of the meaning of the whole painting. The wiping away of the face, the mark of individuality which art from Renaissance portraiture to the Expressionists had lovingly pored over as the defining visible characteristic of the human self, is not only a claim about painterliness but also about the enforced anonymity of the modern city. The model reveals and communicates something fundamental about the nature of experience in contemporary times by means of the action of the paint on the motif. It is both

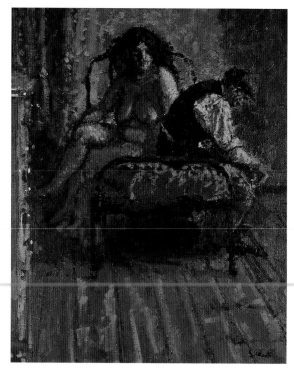

30 *Dawn, Camden Town c.*1909
Oil on canvas
50.6 × 40.2
(19⅞ × 15⅞)
The Earl and Countess of Harewood

38

about the contemporary and about the medium and the two things are linked together in the execution of the painting. That is what makes Sickert modern.

Writing in 1911, Robert Ross reviewed Sickert's important Stafford Gallery show by tackling these issues head on. For Ross, Sickert 'remained one of those "for whom the visible world exists"':

> Usually he will only paint what he sees, though he is careful not to see too much ... The scene must ... satisfy a severe aesthetic formula which admits nothing so artificial as poetry, nothing so obvious as physical beauty, to disturb the functions of paint. Mr Sickert will not condescend to indicate such trivial things as fabrics, nor will he differentiate material or substance. Everything is subordinate to the mediums of oil, pencil or water-colour. Sky, buildings, people, furniture, even, are occasions or mediums themselves for the expression of painting or drawing.[21]

Ross saw clearly that Sickert's realism and attention to subject was subordinate to the imperatives of paint. Everything is reduced in these works to the action of paint across the canvas. It creates a world, building it up into a simulacrum, a fictional, painterly version of reality which can nonetheless tell us truths about the nature of the real. Sickert self-consciously confesses the fictional nature of his medium, but Ross does not see that he makes of that perception the cornerstone of his claims to really see and understand the world. The function of paint is to convert the horrors, macabre realities and occasional epiphanies of experience into a form which enables us to understand it. It is the artist taking 'a piece of flint and wring[ing] out of it drops of attar of roses'. Sickert's painting is about the ways in which paint itself can communicate and understand modern experience.

But we have to be sceptical of these claims. Sickert the 'dispassionate observer' who can collect and comprehend all of the manifestations of the modern world, no matter how unpleasant or how sordid, is his own version of the project. Better, perhaps, to view the project itself, with its manipulative use of the bodies of his working-class models and its fascination with murder and sexual violence, as evidence of the anxieties modern experience induced in Sickert. Reworking the horrors of the world as 'attar of roses' disregards its citizens, women chief among them here, and soothes anxieties by remaking them as empty symbolic vessels which can be tamed and dominated in the brilliant, fluid and articulate paint surfaces of Sickert's Camden Town canvases.

3

MODERNISTS AND AFTER

The Camden Town Murder series brought Sickert right into the heart of con-
temporary British painting and confirmed him as a dynamic senior force in its
development. But this situation, unusual and in fact unique in Sickert's
career, was not to last for long. The impulse towards a 'painting of modern
life', that had been so important for the work Sickert had produced in the early
years of the century, continued to be a major imperative for younger artists in
the years up to 1914. But, artists from generations younger than Sickert's
found this impulse better expressed in the new, experimental art being devel-
oped on the continent of Europe than in Sickert's sophisticated and subtle
realism. The result was that almost at the moment when he found himself a
leading figure in British art, Sickert appeared superseded by newer versions of
modern painting. The history of his career between 1910 and the end of the
1920s is consequently largely a reactive one. During these years Sickert pulled
himself free of the programmatic modernity of subject matter in his earlier
work and reasserted the role of paint as a pure agent of meaning in his pic-
tures. In the early 1920s this situation eased somewhat, but Sickert, suffering
a difficult period in his personal life, began to find a new role for himself only
slowly in the years up to 1926.

In the years immediately after the Camden Town Murder series Sickert con-
tinued to paint the domestic scenes of contemporary life which he had devel-
oped as his own evocation of modern life. *Sunday Afternoon* (fig.25) and *Jack
Ashore* (fig.31) push forward the psychological tension and atmospheric
nuance of works like the 1908 *The New Home* (private collection) and the Cam-
den Town Murder paintings themselves. Now, however, the fraught qualities
of the interaction of the couples in the Murder series have been replaced with
'gently domestic conversation pieces' as Wendy Baron has said of *Jack Ashore*.[1]
The Blue Hat (fig.32), with its light colour and open-faced young woman, offers
an interior and an everyday life which are at the opposite pole to the dark
imaginings of the Camden Town series. These too are everyday lives. Their
sins, events and consequences are all small, easily ignored or dismissed as
irrelevant. Yet now the quality of Sickert's attention insists on the commonal-
ity of the humanity they portray. *Chicken* (fig.33), too, with its gap-toothed
model and celebration of the vulgarity and openness of London life is part of
this fascination of Sickert's with the minor domestic tragedies and triumphs
of the inhabitants of the contemporary urban scene.

These realist statements formed the basis of Sickert's attraction for younger
artists who wished to build on his achievement in defining a modern British
painting. As early as 1907 Sickert's influence had been central to the creation
of a loose, informal association of artists known as the Fitzroy Street Group.

31 *Jack Ashore*
c.1912–13
Oil on canvas
36.8 × 29.8
(14½ × 11¾)
Private collection,
courtesy of
Sotheby's

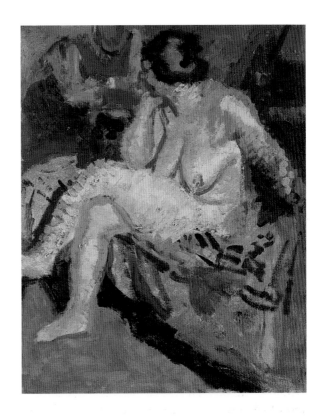

32 *The Blue Hat*
c.1912–13
Oil on canvas
50.7 × 40.6
(20 × 16)
Manchester City Art
Galleries

33 *Chicken* c.1914
Oil on canvas
50.8 × 40.6
(20 × 16)
Private collection

Sickert held regular Saturday afternoon events at 19 Fitzroy Street, which he
billed as 'Mr Sickert at Home'. There, prospective buyers could see work by
artists including Spencer Gore (fig.34), Harold Gilman (fig.35), Ethel Sands
(fig.36), Nan Hudson, William Rothenstein and Lucien Pissarro as well as
Sickert himself. If the Fitzroy Street Group was essentially a way of bringing
disparate work to the notice of potential purchasers, such Edwardian infor-
mality and amateurishness proved increasingly inadequate to the new condi-
tions of the art-world. At the same time that Sickert was developing his
Camden Town Murder series, Roger Fry's 'Manet and the Post-Impressionists'
show in November 1910 and the follow-up 'Second Post-Impressionist' show
in October 1912, both at the Grafton Galleries, asserted the claims of a type of
modern art with which Sickert had little association. The advent of a devel-
oped formal modernism in Britain through the medium of exhibitions which
introduced the British public to Post-Impressionist French modernism provid-
ed a new set of possibilities to younger artists.

Fry's exhibitions – 'the Art Quake of 1910' – have become enshrined in the literature on British art as the moment when modernism really arrived.[2] Although Fry selected works from a generation earlier than the contemporary production of Picasso and Braque, concentrating on Cézanne, Van Gogh, Gauguin, Derain, Denis and others, it is clear that the exhibition seemed to many to portend a thoroughgoing renovation of social and artistic norms in line with a new modernity. The new art was to be visually innovative and experimental, highly subjective, and uninterested in the social realities which had played such a large part in Sickert's paintings and etchings. In response to this new wave of painting, the British art-world entered a period of ferocious competition and association during which the lines of combat were drawn up for the future. Although by 1911 Sickert was being hailed in reviews as 'the Master, or rather the Old Master', after the Grafton Gallery shows the type of modernism represented by Sickert and Fitzroy Street was under attack by a newer version of modern painting which made it seem dull and aesthetically outmoded.[3]

Perhaps feeling threatened by the new conditions, Sickert and his associates formalised the Fitzroy Street Group into the Camden Town Group in the Spring of 1911. The Group began by invitation with sixteen members includ-

34 Spencer Gore
Mornington Crescent
1911
Oil on canvas
63.5 × 76.2
(25 × 30)
Tate

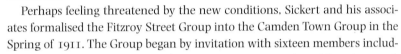

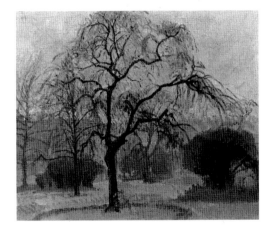

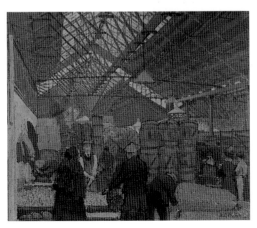

Left
35 Harold Gilman
*Leeds Market c.*1913
Oil on canvas
50.8 × 61 (20 × 24)
Tate

Above
36 Ethel Sands
The Chintz Couch
c.1910
Oil on millboard
46.4 × 38.4
(18¼ × 15⅛)
Tate

43

ing Harold Gilman, Charles Ginner, Spencer Gore, Augustus John, Wyndham Lewis, Lucien Pissarro and Sickert, and held two exhibitions during the same year at the Carfax Gallery. More professionalised and determined than the Fitzroy Street Group had been, the Camden Town Group set out to provide a means for an older version of modernism to stand up in the new competitive arena of modern British art. Camden Town in its core values stood for a realist account of modern life, figurative and determined to show the intimate and everyday domestic details of the modern world. Some of Harold Gilman's very Sickert-like nudes preserve the subject matter of Sickert's North London interiors but transform them with a much brighter and more highly-keyed palette. *Leeds Market* (fig. 35), like Gore's *Mornington Crescent* (fig. 34), focuses on urban experience as its central concern in ways directly derived from Sickert's example. Sands's *The Chintz Couch* (fig. 36) or Sylvia Gosse's *The Sempstress* (c.1914, National Museum of Wales, Cardiff), develop the interior aspect of Sickert's work. Although neither were official members of the all-male sodality of the Camden Town Group their closeness to Sickert is evident here. The interiors present a related account of modernity in the city to the public world painted by Gilman or Gore. Both are connected back into Sickert's example.

Taken in aggregate many of the works of the Camden Town period offer a realist version of the painting of modern life which was the most powerful account available in British painting in the first decade or so of the new century.[4] Like Sickert's own paintings they claimed to offer a pitiless and dispassionate observing eye which might define the intimate circumstances of modern experience for its citizens. But the assertion of such a project already appeared outmoded under the pressure which the increasingly innovative and formally radical modernism of artists like Wyndham Lewis (originally a member of the Camden Town Group) exerted. Paintings like Lewis's *Workshop* (fig. 37), asserted a different modernism to the grim figurative realism of Sickert and the Camden Town Group. These differences led in the end to the absorption of Camden Town into the larger London Group in 1913–14. As the modernists grew to dominance, Sickert got less and less space in the reviews and articles, and the critics dealt more and more with the new and alarming modernity of his juniors. This development led to increasingly frequent arguments between the Sickert faction and the newer modernists whose work he referred to as 'meaningless patterns', and whose factionalism and art-politics he hated.[5] It culminated with Sickert's 1914 resignation from the London Group in revulsion from the art of Lewis and Jacob Epstein.

37 Wyndham Lewis
Workshop 1914–15
Oil on canvas
76.5 × 61
(30⅛ × 24)
Tate

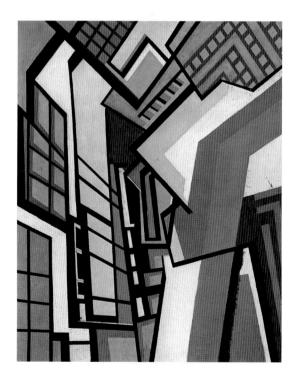

It may be that Sickert was never entirely happy with his role as leader and impresario. Always a loner, the responsibility of a formal, professional role at the head of a new and programmatic younger group of artists failed to suit him. When Gilman and other Camden Towners developed a feverish enthusiasm for Gauguin and Van Gogh (the latter of whom Sickert detested), the rigours of leadership began to appear hardly worth the effort required. Not surprisingly, his reaction to the harshness of the competitive art-world among these 'perfect moderns' (as he called Gore in 1914), was to sidestep it.[6] His resignation from the London Group did not imply any diminution of activity – he had a one-man show at the Carfax Gallery only a few months later and rejoined the New English Art Club at the same time – but it did portend a return of his habitual distance and a reassertion of his independence and uniqueness.

From now on Sickert abandoned the communal activity so widespread in the British art-world in the years before the war and concentrated on his own particularity. Unexpectedly, perhaps, it was one of the results of the advent of the new modernists that Sickert, who had always been seen as significant but contentious and radical, began to be written about as a respectable, almost a traditional, figure. It may be that this change, too, pushed Sickert back towards his own concerns as an individual artist. Perhaps intent on reinvigorating himself at the site of his early inspiration, he seems to have intended to move back to France, probably for an extended period, but this plan was cut short by the outbreak of war in August 1914. Always preferring to tease, to occupy the ironist's place on the sidelines and to reserve commitment for subtle and humourous judgement, Sickert abandoned his career as impresario.

Under the pressure of these developments Sickert began a process of change and renovation which was to set much of the agenda for the remainder of his career. The first evidence of this was the important painting he exhibited at the NEAC's Winter exhibition for 1914 after his return to England from France. In common with many other artists, however radical their pre-war activities, Sickert was very swift to assert that his art was supportive of the war-effort. *The Soldiers of King Albert the Ready* (fig.38) shows Belgian soldiers defending their country from the German invasion. Sickert was well aware of its topicality, stating that 'I want to do something for them and it will probably be all I can do'.[7] The painting was received in the same spirit. The *Morning Post* was typical in welcoming Sickert's renunciation of 'his brooding on the ironies and the satiated joys of unfortunate people' in favour of the 'representation of nobler specimens of humanity'. The critic felt that on this showing 'Mr Sickert might well become the first great military painter of England' and the *Athenaeum* thought it was 'the only painting provoked by the present war ... which has artistic value'.[8] The significance of the painting, however, lies not so much in this very widespread artistic patriotism but in the technical innovations Sickert deployed in the canvas.

The Soldiers of King Albert is of 'crucial' importance in Sickert's oeuvre, according to Wendy Baron, because it is the first in which we can be sure he made use of the technique which formed the basis of his painting for the remainder of his lifetime. The technique consisted of preparation of the

painting with a 'camaïeux tonal underpainting', a two-colour application of paint without modelling and with one colour (white with cobalt) describing the lights and the second (white with indian red in various strengths) describing the shadows.[9] Once the composition and tonal relationships of the canvas had been satisfactorily established by repeated reworking in these colours 'you just slip the last skin of colour on', in Sickert's words, adding the colour to the composition by means of scumbled pigment applied over the camaïeux underpainting.[10] The advantage of this was the chance it gave to revise the composition more or less at will by adding paint on top of the camaïeux rather than scraping down what had been intended as a final coat. The result is a paint surface formed by many coats, patches of one colour showing through 'the thinly scumbled colour of succeeding coats'.[11] This gives the characteristic

effect, visible in *The Soldiers of King Albert* and in its companion piece, *The Integrity of Belgium* (1914, Government Art Collection), of a highly worked and coloured surface. Sickert never departed very far from this technique after 1914. It represents the culmination of the repudiation of Whistler's Impressionism which had begun when he started to compose through preparatory drawings under the influence of Degas. Sickert was later to claim continuity with old master technique, and in 1914 the elaboration of such a procedure was an assertion almost of anti-modernity. Although he was fond of urging this discovery on his fellow artists – 'I have certainly solved the question of technique and if you would all listen it would save you 15 years muddling', he wrote to the painter Nina Hamnett in 1918 – Sickert was in fact involving himself in his own, private concerns as an artist rather than in the larger arena of art-politics.[12]

Brighton Pierrots (fig.39) shows Sickert putting this newly developed technique to work on a more familiar subject for him than warfare, and in the process developing both the possibilities of the technique and the meanings of the motif. Like earlier periods of his work, *Brighton Pierrots* presents one of Sickert's favourite themes, a mix of stage, theatricality and performance. Now, however, the gloomy interiors and dramatic artificial light of earlier images has been replaced by the brilliant colour of Sickert's new technique as he depicts a wartime performance outside, on the beach front. It has been suggested that the empty line of deck chairs to which the performers are playing represents the impact of the war, proceeding over the channel and casting a pall over the empty forms of entertainment which are acted out before a reduced and perhaps distracted audience.[13] Certainly the crepuscular sky and the effect of the nearest pillar, slicing through the jerking body of the pierrot in the foreground, reinforce the sense of melancholy and unease which the painting communicates. Despite the brilliance of the colour compared to Sickert's earlier paintings, *Brighton Pierrots* is subdued rather than lively, a vivid but pessimistic vision of performance in time of war.

This emotional quality and the tension between it and the brilliant colour of the painting suggest a relationship to Sickert's own position at the time. Sidelined to some extent from the accelerating developments in modern English painting, his own performance might well have temporarily taken on a sense of melancholy for him. It must have been hard for Sickert in his midfifties to feel that he was superseded by the young and confined to the role of respected but uncontentious establishment figure. As the subtlety and complexity of achievement built up over the previous thirty years of constant endeavour was being flattened into two dimensions in the minds of the public and art critics, his art became useful to the new painters only as rhetorical ammunition in their own wars and clamourings for position.

Sickert's interest, briefly dominant at this time and then abandoned forever after 1930, in etching and etching technique is another part of this same situation. Sickert had continued to etch after his apprenticeship to Whistler, and many of his most famous compositions have their graphic partners, such as the 1906 version of *Noctes Ambrosianae* in etching and drypoint, or were explored further through this medium. In 1915, however, as he withdrew from

the frantic competition to paint modern life around him, Sickert began to
spend increasing amounts of his time at his etching desk, standing there 'from
10 to 5, with very little break' as he wrote to Ethel Sands. In doing this, he was
building not only on his earlier etched work, but also on a considerable body
of theoretical work on etching technique and practice which he had published
in the art press over the previous ten years. On the basis of this fascination he
was able to come to an arrangement with the Carfax Gallery which agreed to
print and publish a series of sixteen etchings which he would execute, and this
gave Sickert the opportunity to explore the medium in a concentrated way
during the war years.[14]

Sickert's interest in the tonal and unmodelled underpainting of the
camaïeux is carried over into the technical innovations of this period of his
etching. Whereas in earlier etchings Sickert had made use of a variety of
means to achieve effects of light and shadow, tone in these prints is achieved
entirely through the use of hatching across the visible white of the paper. Line
carries the implication of tonality here as an equivalent of the patterns of
tone Sickert set out in his paintings, an effect which can be clearly observed in
the complicated network of hatching visible in *Femme de Lettres* (fig.40),
where modelling is achieved by discrete areas of etched lines. As one of

39 *Brighton Pierrots*
1915
Oil on canvas
63.5 × 76.2
(25 × 30)
Tate

Sickert's historians in this medium, Aimée Troyen, has observed, the technical experiments that Sickert undertook at this time push the quality of his etched work towards the abstract. Interest is in line and form for their own sake at the expense of subject, since 'their main interest and beauty is to be found in the shapes and textures of the patterned areas and the rhythms of spaces and intervals between them'.[15] As with the move in his oil painting towards increasing experimentation and concern with the technical aspects of execution at the expense of subject matter, etching functions for Sickert at this time as an alternative to the more public arena where the painting of modern life had been taken up.

The Carfax series of etchings proved to be a financial failure and, perhaps in response, Sickert turned back to oil painting in 1916. He continued to etch until the end of the 1930s, but it never again took such a central position in his art, and he seems by then to have abandoned the medium permanently. Nevertheless, Sickert's wish to experiment and the delicacy and subtlety of much of his handling make him a significant figure in the history of British printmaking.

The years immediately after the end of the First World War were troubled ones in Sickert's biography as well as his art. In 1911 he had married for the second time (he and his first wife, Ellen Cobden, had divorced in 1899). His new wife was Christine Angus. The daughter of a businessman, she had attended one of the art schools Sickert periodically ran throughout his life. Confined to Britain during the War, the Sickerts spent time outside London at Chagford in Devon and at Bath. The latter provoked Sickert to rhapsody, 'such country and *such* town' he wrote to Ethel Sands in 1918, and he made a number of paintings and studies there as well as graphic works, all of which concentrate on architectural 'town' and 'country' landscape subjects.[16] *Pultney Bridge, Bath* (fig.41) renders the famous view in the brilliant colour-scheme of Sickert's new style, exploiting to the full the capacity of his technique to achieve a combination of precision and colour. For the first time, Sickert was looking outside the fervid modernity of London's urban scene or French equivalents. His attraction to Bath and his evocation of its traditional qualities

40 *Femme de Lettres*
1915
Etching
15 × 18 (5⅞ × 7⅛)
Metropolitan
Museum of Art, New
York

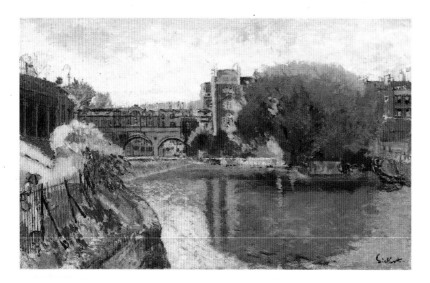

41 *Pultney Bridge, Bath c.*1917
Oil on canvas
72.4 × 115
(28½ × 45¼)
Yale Center for
British Art, Paul
Mellon Collection

is another indication of his withdrawal to new interests and attitudes. 'There never was *such* a place for rest and comfort and leisurely work', he wrote in the same letter to Ethel Sands.[17]

However much they liked Bath, once the war had ended the Sickerts could look abroad again. They left the country in 1919 for France where they apparently intended to live permanently. The couple settled at Envermeu, just outside Dieppe, where they had owned a house since 1912 but which they had been obliged to abandon soon after the outbreak of war. Whatever plans Sickert had formed did not last long, for Christine Sickert died in 1920 of tuberculosis. The effect of this sudden death on Sickert was very great, and seems to have been compounded when his mother also died in 1922. Emotionally disturbed and off balance, Sickert was unable to remain in Envermeu. After his wife's death he moved first to Dieppe and then, in 1922, he returned to London, taking a series of rooms and studios largely around his old haunts in Fitzrovia and Camden Town.

Sickert's behaviour and appearance had been exciting comment long before his wife's death, but it was during these years that the 'Sickert legend' of eccentric behaviour and unusual clothing was properly formed. There are many versions of this legend, including accounts of Sickert's famous conversation and verbal wit, from Lillian Browse's account of him in the 1930s, 'in an old trench-coat and an ancient straw hat with broken brim', his trousers crammed into 'brown leather army boots' with no laces, haunting the Caledonian Market, to his artists' supplier remembering Sickert 'coming to the shop in various disguises, sometimes clean shaven, sometimes with a beard, sometimes a real "Piccadilly swell", sometimes an old tramp or country farmer'.[18] In the later 1920s he was always writing to the press, in favour of the kilt as an item of dress, to defend the beauty of gasometers or petrol pumps, or to announce the formation of the men's dress reform party. These eccentricities were reinforced and confirmed at this period, if they were not initiated then. Denys Sutton his biographer believes that by the time he returned to London in 1922 'his mind was disturbed and he seems to have

undergone some form of mental breakdown', which manifested itself in a new inwardness and in a physical compulsion to lock everything away. He put up steel gates across the entrance to his studio and bought a large dog to further discourage anybody who penetrated beyond them.[19] Sickert's distance and self-sufficiency, always vital to his personality, now became negative, for a while neurotic, and in a sense destructive.

42 *Vernet's Dieppe*
*c.*1920
Oil on canvas
61 × 49 (24 × 19¼)
Private collection

Sickert's gradual emergence from this low point of his life was marked by his election as an Associate of the Royal Academy in 1924 and by his marriage to the painter Thérèse Lessore in 1926. Sickert had frequently spoken well of academic artists in the past. Unhappy with the new modernists of the London Group, he had used his opening speech at the 1913–14 Brighton show of their work to praise the Royal Academy and academic artists like Sir Edward Poynter. Already in 1912 he had declared that 'the kind of ordered and conscious accomplishment represented by' the academician Sir Frederic Leighton's picture *Summer Moon* 'was the real road of art, the only road for students to tread in order that they might become masters'.[20] In 1917 he had been enthused to move into the studio at 15 Fitzroy Street where the Victorian Academician W.P. Frith had painted his famous *Derby Day* (1858), and when he returned to London in 1922 he went back to 'The Frith' as he called it. Proposed for the Academy in 1924 by the painter William Orpen, Sickert was delighted to become an ARA, and instantly began to sign every available picture with his new initials. Although there was some surprise at his election in the press – 'Mr Walter Sickert an ARA, it seems incredible', wrote one paper – others thought it was 'long overdue' and 'an honour that has been his any time these last thirty years'.[21]

Sickert marked this change in his fortunes by changing his name. He had always been known as Walter Sickert, but he now began to call himself first Walter Richard and then simply Richard Sickert. I have already cited Wendy Baron who believes, convincingly enough, that this is evidence of 'a deep desire to change his identity'. The turmoil of the war, his second wife's death and the abandonment of his hopes for a life in France, the necessity of bidding farewell to Dieppe the scene of his youth, all had occurred when Sickert was in his early sixties. That he recovered at all argues for his resilience and will for life.

Sickert's difficulties and lack of focus at this time make it hard to point to coherent interests in his work, but there are many effective and successful individual paintings. While he was in Dieppe after his wife's death and before his return to London in 1922, Sickert made a number of paintings of Dieppe interiors. Some were of unfamiliar subjects, such as *Baccarat* (1920, private collection), with its fashionable well-to-do gamblers, others such as the *café-chantant* in *Vernet's Dieppe* (fig.42), or *Au Caboulot au Bout de Quai* (c.1920, Montreal, Museum of Fine Arts), are reminiscent of his earlier subject matter in the music-halls of London and Paris. These paintings all show the heightened tone and developed technique of his later works. *Vernet's Dieppe* perpetuates the sense of indeterminacy in subject matter and event of the earlier works, the exiting half-figure visible at the extreme right perhaps serving as a witty metaphor for the painter himself, once more in transit and at a point of change.

The intense colour and vivid execution are present as well in the *Portrait of Victor Lecourt* (fig.43), with which Sickert made his proper debut as an ARA at the 1925 Royal Academy Summer Exhibition. Here Sickert takes a subject as unimportant as any of his earlier models in the Camden Town paintings – Lecourt owned a local restaurant, and was unknown to Sickert's audience

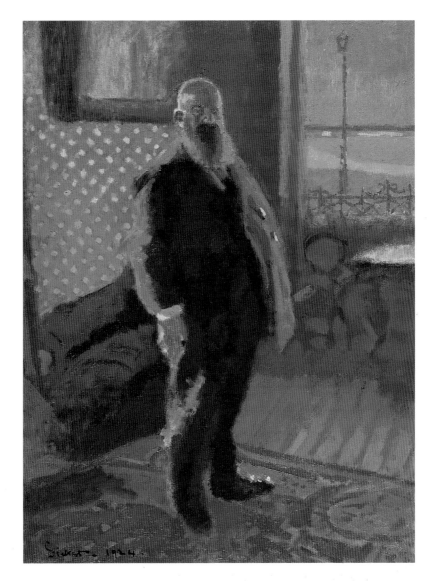

43 *Portrait of Victor
Lecourt* 1921–24
Oil on canvas
81.3 × 60.5
(32 × 23⅞)
Manchester City Art
Galleries

even by reputation – and translates him within his environment to a frank
dignity and self-possession. Although there were some dismissals in the
reviews on the grounds that the subject was insignificant or risible, the bal-
ance of comment praised the picture for its painterly mastery and integrity
in observation and application. The contrast between the experiment and
novelty of the *Lecourt* and the conventional society portraits of the exhibition
were favourably noticed, and the verve and excitement of the painting won
him admirers. Richard Shone sees the exhibition of this painting as 'a turning
point in Sickert's public profile', and it is certainly at this moment that the
combination of Sickert's eccentricity, boldness and originality as a painter and
capacity for self-promotion and self-assertion combined to give rise not only to
the 'Sickert legend' but to a new and productive final phase of his career.[22]

4

TRADITION AND INNOVATION

In the period that begins in the late 1920s and continues until Sickert's death in 1942, there is a sense of retrenchment from the world, coupled with a continuing and dramatic creativity in the work. Sickert began these years by undergoing some form of breakdown after the death of his second wife, Christine. When in 1926 he married for the third and last time, to the painter Thérèse Lessore, this mental turmoil appeared to subside, but seemed to translate itself to the physical aspect of his health, for Sickert suffered a serious illness from which his recovery was slow and uncertain. When he began to paint again in 1927 the works he produced heralded a new creativity but also a darker concern with the self and its isolation in the world. 'Economy of means is a sign of the greatest craftsmanship in art', Sickert wrote around this time in his lecture 'Straws from Cumberland Market', and went on to say that 'the finest literature is that which expresses most in fewest words, and the greatest paintings express most with the minimum of substance. One of the delights of art is the joy of seeing effect produced with an economy of means.'[1] This elegance and refinement had remained with Sickert as a central pillar of his aesthetic throughout his career. In the late phases of his life, his art took on these qualities above all others. His earlier preoccupation with the impulse to paint modern life wanes, although it does not disappear, to be overtaken by the interest in the craftsmanlike technical processes and possibilities of paint itself which, always present, now become predominant.

During the 1930s Sickert began to make a series of works based on Victorian art which became known as 'English Echoes'. *Summer Lightning* (fig.44) derives from an engraving by the Victorian illustrator Sir John Gilbert (fig.45) who had worked for the *Illustrated London News*. These Echoes have 'always been the most controversial part of his *oeuvre*', as his most recent commentators note.[2] Painted and exhibited in the 1930s at the height of the twentieth century's repudiation of the Victorian past, they continue to seem to many viewers to be the essence of kitsch, the recycling of embarrassingly unselfconscious celebrations of Victorian narrative art in a manner that is insufficiently distinct from its models to justify itself as irony. Sickert has seemed to take these works and their utilitarian, illustrative tradition too seriously. Moreover, the emphasis on a particularly English line of art, narrative and popular rather than refined, has reinforced a certain lack of sympathy on the part of Sickert's critics.

In *Summer Lightning* Sickert remains very faithful to the line of his original, transcribing most of the descriptive details of the engraving onto his canvas and only cropping the bottom of the image to bring the startled heroine forward towards the viewer. But despite this fidelity, under the pressure of

Sickert's attention Gilbert's *The Unexpected Rencontre* becomes something different from its original, something more modern and less confident. The tonal gradations and narrative tension which were the high points of Gilbert's skill as an illustrator are both undone in Sickert's version. In their place, Sickert offers a refined colour and picture surface, one effect of which is to pull apart the ghostly male figure from the responses of the heroine who seems almost to be reacting to something else entirely. The decision to insert these eerie Victorian survivors into a landscape and summer colour which suggest Fauvism rather than the grey world of nineteenth-century materialism, switches

44 *Summer Lightning* c.1931–32
Oil and pencil on canvas
62.7 × 72.3
(24⅝ × 28½)
Board of Trustees of the National Museums and Galleries on Merseyside (Walker Art Gallery

45 Sir John Gilbert
The Unexpected Rencontre
Reproduced in *The Illustrated London News*, 9 April 1932

55

attention to the formal and downplays story and imitation. Narrative and realism are not the issues of Sickert's picture. It replaces them with values more familiar to modernist works, the drama of paint surface, colour, form and line.

Idyll of c.1931–2 (fig.46), based on Gilbert's An Embarrassing Moment (fig.47), executes the same manoeuvre, setting the Victorian narrative crux within a chalky, bleached landscape which looks as if it is drenched by a strong Mediterranean sun. The retreating horse, cart and rider become flattened and decorative elements in a post-Impressionist canvas. The two Victorian protagonists mime the possibility of a narrative, a story or crucial event, but their scrubbily painted faces and the elegant, summary lines Sickert chooses to describe their movements, present us with a newer world where such comforting possibilities of meaning are no longer sustainable. Sickert's 'Echoes' repeat their originals, true, but in a new set of circumstances where the resonances of the model are increasingly distant and inaudible. Sickert can repeat the actions, transcribe the lines and positions of bodies as they engage in some once-meaningful Victorian ritual of embarrassment, triumph or tense but suppressed eroticism. But what emerges from that repetition is a demonstration that these actions, this visual language of plain narrative and secure society, are no longer meaningful when seen through modern eyes.

From this point of view, Sickert's interest in these works is a quintessentially modern interest. It is to do with the refinement and articulacy of art itself, the brushstrokes, the nuanced and sophisticated application of paint onto the canvases, distributed in a way that is concerned with a refinement of sensibility and response. Summer Lightning uses its ready-made subject as a way of putting subject to one side. It is an assertion of the value and interest of art, paint itself. The visual and material qualities of paint are so thoroughly foregrounded in this process that art itself becomes the subject matter of these paintings, because the possibility of narrative, of anecdote, story and social meaning have all been compromised, eroded by the action of modern life. All that is left when these things have gone is art itself. It is a central modernist position.

But if Sickert's achievement in the 'Echoes' is apparently modernist, his humour in the series is directed at least as much towards the moderns as towards the Victorian originals. 'I confess also to a desire to do a little propaganda by sending the younger painters to rifle the English sources of inspiration,' he wrote.[3] Sickert's perennial temptation to mock received wisdom no doubt plays a part in this. His devotion to illustration in the popular press, learnt from his father who spent the early part of his career doing just this as an illustrator on the Munich comic newspaper, the Fliegende Blätter, must also have been instrumental. Sickert defended illustrators throughout his life, sometimes elevating them to the status of leading modern artists. Clive Bell's superior judgement that Sickert was 'playing the fool' in the 'Echoes' was an indication for Sickert of the ignorance of the over-sophisticated critic.[4] The immediate popularity of both the originals and the 'Echoes' with the public stood for a kind of vindication of his sense that important and impressive art could be made even in places and at times at which the refined nostrils of the modernist critics curled.

Writing a series of notes on his favourite illustrators for the 1931 Leicester Galleries exhibition of 'English Echoes', Sickert was plain about this, after his fashion. The *Punch* illustrator Kenny Meadows 'will probably be best known by his illustrations of Byron, with whose delightful brand of flippant and inspired vulgarity he was fitted with precision to identify his pencil'. Gilbert 'was master of romantic and melodramatic subjects ... His pencil shone with equal facility in low-life, colonial subjects, and in dazzling saloons of the aristocracy'.[5] As these comments suggest, Sickert had in part a craftsmanlike appreciation of the skill of his Victorian predecessors in achieving popular

46 *Idyll* c.1931–2
Oil on canvas
81.4 × 85.2
(32 × 33½)
Ferens Art Gallery

47 Sir John Gilbert
*An Embarrassing
Moment*
Reproduced in *The
Illustrated London
News*, 9 April 1932

imagery with talent and vivacity. Frustrated by the possibilities of narrative in the pictures themselves, Sickert constructs narratives through the lens of a self-conscious and self-ironising nostalgia. 'To the translator it seems impossible', he wrote, 'that Alfred Bryan should need a biographical note. Was not the window in Wellington Street of the *Entr'acte* Office the paradise of the art-lover in London for more years than can be counted? And the pages of the *Era* ...? And the little paper called *Moonshine?*'[6] It is as if the recounting, however summarily, of the lives and triumphs of these forgotten Victorians, so thoroughly out of high-fashion at the time Sickert wrote and painted these works, could rescue meaning from its attrition in the

48 *King George V and Major Featherstonhaugh at Aintree c.*1927–30
Oil on canvas
47 × 47
(18½ × 18½)
The Royal Collection, Her Majesty Queen Elizabeth II

modern world. But even here Sickert's tongue is wedged firmly into his cheek. 'She was obliged to make thirteen replicas of her picture entitled "Little Nell",' he writes deadpan of Adelaide Claxton, another of his illustrators.[7] After Oscar Wilde's comment that no one could read the passage on the pitiful death of Nell in Dickens' *The Old Curiosity Shop* without laughing, Claxton's qualifications as an illustrator of the scene were unlikely to impress Sickert's self-consciously twentieth-century audience. Sickert's stringent pro-Victorianism was teasing, earnest and self-ironising simultaneously.

Sickert's dandyism and refinement as a painter found another expression at this period of his career through the use of photographs. Like the 'Echoes', his paintings copied from photographs depend on the idea of transcription or 'translation' as Sickert was inclined to see it, 'claiming thereby the same liberty as Pope ... with Homer, Virgil with Homer, Fitzgerald in the Omar Khayyam' and other famous literary translations.[8] Sickert asserts that a mechanical idiom characterised by reproduction of the image, which describes both periodical illustration and photography in their different ways, could be transformed into the uniqueness of a painting signed with his flourishing signature.

Sickert's biographer, Robert Emmons, assigns *The Soldiers of King Albert the Ready* (fig.38), to origins in a newspaper photograph, and Sickert had certainly made use of photographs as a source for his compositions for some years.[9] But in the late stages of his career this interest became central to his working methods and to the appearance of many of his canvases. *King George V and Major Featherstonhaugh at Aintree* (fig.48) derives its composition directly from a photograph. In both these works the impulse to make the work a transcript of the original appears overtly visible. Sickert's intervention in composition and impact seems minimal. The photographs were squared up and then translated to the canvases where in many cases the grid-work marks of the

50 *Miss Gwen
Ffrangçon-Davies as
Isabella of France*
1932
Oil on canvas
245.1 × 92.1
(96½ × 36¼)
Tate

49 *Gwen Ffrangçon-
Davies in 'Edward II'*
Photograph,
published in *Vogue*,
December 1923

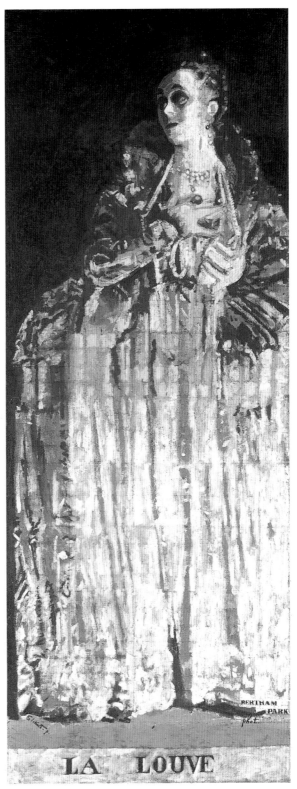

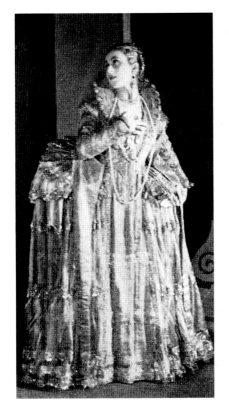

LA LOUVE

squaring up can be clearly seen in the finished picture (fig.1). Sometimes, as with *The Miner* (c.1935, Birmingham City Museums and Art Gallery), the original of which is unknown, Sickert identifies dramatic or intense compositions in his sources that he then makes use of in structuring the work. Sometimes, the impulse seems more purely documentary or passive.

This use of ready-made materials as central elements of his pictures has sometimes given rise to worries about the propriety of Sickert's late work. Commentators are inclined to feel that use of a photograph amounts to dependence and argues a failure of creative power. But attention to the most successful of the many paintings he produced using these methods suggests otherwise. When he took a press photograph of the actress Gwen Ffrangçon-Davies from *Vogue* (fig.49) he chose a moment of dramatic tension, commenting on the image which he selected from a sheaf of others in her press-cutting book, 'yes, this is good'.[10] Once the photograph had been through the process of squaring up and translation onto the canvas Sickert's artistic intervention was clearly visible in the end result. The actress, shown as Isabella of France in Marlowe's play, *Edward II* (fig.50), is described against a dense background which avoids the stage-setting of the photograph, in a ghostly white through which Sickert's squaring up lines clearly show in the skirt. Sickert crops the photograph to bring the figure forward and to heighten the drama of the moment, consciously imitating the practice of photographers and editors, and he transforms the elegant posture and fluttering passivity of Ffrangçon-Davies in the original into a sinister, pained tension, pushing the hair back from the brow and changing the position of the left hand and arm to convey a jerky nervousness absent from the photograph.

Characteristically, Sickert includes a transcription of the photographer's name at bottom right, but the authority in this painting is clearly all the painter's own. Throughout his career the preservation of squaring up lines into the final state of the canvas seems to have meant for Sickert an assertion of the painter's power and constructive capacity. These visible reminders of Sickert's presence and the contribution of the artist serve to emphasise the role of art in these works. The most unequivocal statement of this authority and the priority of the painter's artistic decisions and touch is in the paint technique which Sickert uses. Wendy Baron has noted that the recourse to photographs may have had its origins in technical preferences Sickert had long displayed. Photographs are unlike drawings in having no linear elements. Form is made entirely out of tonal contrast. Baron suggests that this 'purely tonal a-linear character of the photograph confirmed Sickert's tendency to convey the full sense of plastic form solely by means of tone, colour and the direction of brushwork', which was the emphasis of the camaïeux technique he had developed after 1914. During these years, under the impact of this use of photographs as technical media of visual communication, Sickert 'dispensed entirely with linear accents, presenting his subject as an abstract and shaggily interwoven map of tonally precise, but arbitrarily coloured, patches and stains of pigment'. Paradoxically, the increased use of photographs after the mid-1920s allowed Sickert a greater freedom to assert the constructive and dynamic qualities of paint as substance. The capacity of

51 *Miss Earhart's
Arrival* 1932
Oil on canvas
71.7 × 183.2
(28¼ × 72⅛)
Tate

paint to form and communicate a vision of the world is powerfully asserted through these liberated technical processes and, in this sense, it is clearly the case that the use of found materials as a base for compositions led Sickert farther into a set of positions which he had espoused from the beginning of his career. Photographs are not only documentary but also, in the limited sense which Wendy Baron allows us to perceive, technical procedures which are conducive to the interest in the autonomous and separate sphere of art practice, which was one of Sickert's major concerns throughout his life.[11]

There are multiple ironies in this. Following the German critical theorist Walter Benjamin, one strand of thinking about the role of art in modern life has asserted that in 'an age of mechanical reproduction' art must lose its 'aura', the uniqueness of the single unreproducible object.[12] It might be helpful to read Sickert's engagement with the reproductive process of photography as protesting against this situation. Sickert explicitly takes the mass or popular culture represented by the photograph and reinscribes the aura within it by the 'translation' or transformation he enacts in his art. The process of 'squaring-up', also mechanical, stands for Sickert for the long tradition of auratic art, running back to the old masters, and therefore asserts the uniqueness of the eventual object rather than its reproducibility. Sickert uses the mass-reproduced object, but intends to make of it a work of art in a more traditional sense.

Miss Gwen Ffrangcon-Davies was instantly popular and successful, but the same process of creation is visible in another work which was comparatively ill-received as too literal and hasty, evidence of 'the intellectual passivity which has now for some time made this brilliant artist a slave of the camera'.[13] *Miss Earhart's Arrival* (fig.51) again crops and manipulates its original, this time from *The Daily Sketch* for 23 May 1932. Sickert focuses on the central episode, burying the heroine – Amelia Earhart the first woman to fly solo across the Atlantic – in the depths of the crowd, and producing a jazzy, jagged, modern image, stark and hurried and with the dark implications characteristic of much of Sickert's work at this time. There is little of triumph or celebration in this rain-sodden crowd. The event they are pushing forward to witness might as well be a tragedy. The press were disconcerted when Sickert revealed that his painting had taken five days to produce, complaining that such a

hasty execution was bound to be inadequate. But, however brief the period Sickert spent working on the picture, in fact the impact of *Miss Earhart's Arrival* is strong. Sickert delights in a contemporary subject and contrives a visual equivalent of its modernity which allows a troubling emotional tone to gather around what seems on the face of it to be occasion for unadulterated celebration.

The art historian James Elkins has recently written about the ways in which the physical substance of paint provides a means of embodying thinking which is different from our normal verbal means but as effective. Elkins sees paint as the responsive substance which records the thinking our body does as we work with it.

> Paint records the most delicate gesture and the most tense ... Paint is a cast made of the painter's movements, a portrait of the painter's body and thoughts. The muddy moods of oil paints are the painter's muddy humours, and its brilliant transformations are the painter's unexpected discoveries. Painting is an unspoken and largely unrecognized dialogue, where paint speaks silently in masses and colors and the artist responds in moods. [Paintings] preserve the memory of the tired bodies that made them, the quick jabs, the exhausted truces, the careful nourishing gestures ... Paint is water and stone, and it is also liquid thought.[14]

It seems to me that this captures the attitude which Sickert, who declared that '"technique and material" are surely as much the terms of art as words of thought', felt and lived in his paint throughout his career.[15] Because paint is so sensitive a language of the thinking of the body, its impact on what it represents constitutes a transformation, a reprocessing of the material in a newly perceived and understood form. Sickert's photographic works are partly about this capacity to transform. Whether it is through the introduction of emotional implication or through the clear evidence of the constructive hand of the artist, squaring up and 'translating' from one medium to another, Sickert asserts the painter's capacity to make the world. The most powerful element of these paintings considered as a series is the insertion of idiosyncratic or non-naturalistic colour and the presence of overt paintwork, visibly applied and worked over with the brush. The found quality of the subject and initial kernel of the compositions become the base on which Sickert is able to build paintings which are emphatically his own creations and which offer understanding about their subjects different from those of their photographic models.

Partly driven by financial necessity, Sickert painted a number of portraits during this period of his career. Although they are commercial works for the most part, they include penetrating views of personalities and a persistent theme of the splendour which can come with personal isolation. Once again, Sickert turned to photographs to aid his work, sometimes to the exclusion of formal sittings. The subject of *The Viscount Castlerosse* (fig.52), recalled that they had a good lunch together, before which 'Mrs Sickert took a snapshot or two, and that was all that was asked of me'.[16] Portraits like *King George V and*

Major Feathersonhaugh at Aintree (fig.48) or *H.M. King Edward VIII* (1936, The Beaverbrook Foundation) were made entirely from photographs, as was *Lord Beaverbrook* (1934–5, National Portrait Gallery). The latter, like *Castlerosse* was part of a never completed twelve-portrait commission for Sir James Dunn, a wealthy Canadian financier. The volatile combination of Sickert's powerful sense of his own authority in matters of painting, his slowness and reliance on his own judgement and rhythm, and Dunn's imperiousness and command meant that the relationship broke down quite quickly. It is another instance of Sickert's determination to rule matters relating to painting without reference to the wishes or opinions of others. Sickert's teasing and distant personality

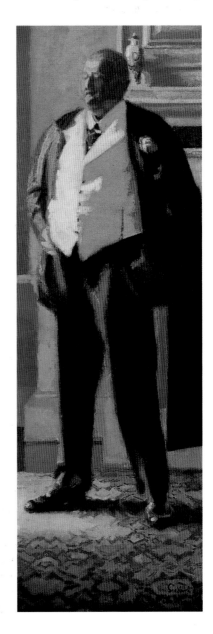

52 *The Viscount Castlerosse* 1935
Oil on canvas
210.8 × 70.2
(83 × 27⅝)
The Beaverbrook
Foundation,
Beaverbrook Art
Gallery,
Frederickton, N. B.,
Canada

was ill-fitted to the role of financial supplicant, and he was unable or unwilling to accommodate himself to the necessities of working on commission in this way. The decision to place Beaverbrook against 'the dramatic, if unlikely, background of Margate Harbour', as Richard Shone has put it, is perhaps a typically tongue-in-cheek assertion of this freedom and capacity to make decisions by the painter.[17] The portraits for Sickert are paintings before they are documents or records of the personalities of his sitters.

In many of the portraits, Sickert adopts Whistler's slim full-length format and a version of his brevity and summary execution of features and personality. In important ways, *Castlerosse* and even *Beaverbrook* are conceived as compositions and pure distributions of colour across the surface of the painting. As Richard Shone has pointed out, *Castlerosse* draws on the colourist heritage of Venetian painting, and the effect of this is to produce a powerful claim for painting over individuality.[18] Sickert's determination to insert the personalities of his sitters into highly structured and painterly compositions, produces a cumulative feeling of the isolation and abnegation of the individual. 'No one could tell it was a portrait,' recalled Lady Berwick of *Lady in Blue: Portrait of Lady Berwick* (fig.53), 'it is a fantasia in a characteristic subdued colour scheme.'[19] If this comment overstates the case, it is nevertheless true that even in apparently pungent evocations of personality like the Castlerosse portrait Sickert's determined and assertive paintwork takes the leading role and subordinates the sitter to a decorative, colouristic or painterly order which is linked to a record of isolated and atomised individuality.[20]

Among the most spectacular of these portraits is that of the novelist *Sir Hugh Walpole* (fig.54), a second version of his subject made after Sickert had produced a more formal portrait now in the Fitzwilliam Museum in Cambridge. The Glasgow portrait is much looser in handling and pose than the one in Cambridge, the author leaning back in his chair perhaps at some point of rest during or after a sitting and captured by the photograph from which Sickert took the image. The paintwork is overt and confident, describing the subject effectively and yet in the most summary and non-naturalistic way. Walpole's analytic and self-contained personality clearly emerges from the description, which nonetheless remains firmly a statement of the capacities of paint itself to function and bear meaning. *Sir Hugh Walpole* is also about the resistance to knowledge of others. Like Sickert himself, Walpole seems here a characteristically distant and unknowable self. The spontaneity and description of a

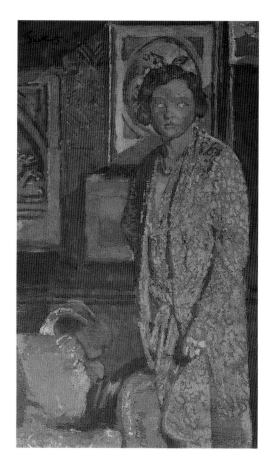

53 *Lady in Blue: Portrait of Lady Berwick* 1933
Oil on canvas
152.5 × 91.5
(60 × 36)
Attingham Park, National Trust

54 *Sir Hugh Walpole*
1929
Oil on canvas
76.2 × 63.5
(30 × 25)
Glasgow Museums:
Art Gallery &
Museum,
Kelvingrove

strong self caught at a characteristic moment seem distanced from us by the emphatic paint surface even as it allows us access. The brilliance of this portrait lies in its combination of declared paintwork, penetrating communication of the quality of the personality and, at the same time, acknowledgement of the impossibility of ever truly knowing the subject of a portrait.

During the 1920s and 1930s, Sickert produced a number of self-portraits which explore further his fascination with the unknowableness of the self and the rebarbative quality of the images which others and the self project. Sickert had painted himself at earlier stages of his life, as *The Juvenile Lead* (aged forty-seven) (1907, Southampton City Art Gallery), or in *The Painter in his Studio* (1907, Art Gallery of Hamilton, Ontario), frequently mocking his confident image or making direct reference to his career as an actor. But, as Richard Shone has noted, at this period 'the theatrical element detectable in ... earlier work gains extravagant ascendence' as Sickert paints himself in a variety of wonderful roles, from flirtatious oldster in *The Rural Dean* (c.1932, Scottish National Gallery of Modern Art) to the lowering, sullen presence of *The Domestic Bully* (c.1935–8, private collection) or, as in *Home Life* (1937, private collection), a benign old man swinging open the door of his wine cellar with one hip and filling his hands with bottles for the table.[21] Richard Morphet points to the dark aspects of these self-portraits. He comments on them as 'distinctly uncomfortable as projections of human situations [which] emphasise rather than accept the pathos of old age, and treat of illness, suffering and tribulation' and sees them as suggesting 'a sense almost of alienation', which is even more acutely expressed here than in his portraits of other sitters.[22] The

broken-down figure tapping his way fitfully along the Piccadilly pavement in *Self-Portrait in Grisaille* (fig.55), is an extreme version of this. Sickert presents his self as disastrously in dissolution. The eccentricity of the Sickert 'legend', loud suit, idiosyncratic gait and all, is shown as incapable of sustaining the self against the deleterious effects of age. Passers-by hurry indifferently around him, his colourful larger-than-life quality dwindled to a sad monochrome. The figure in grisaille is a powerful image of isolation.

The most compelling of these self-portraits however were made a few years before this when Sickert painted three extraordinary views of the self in old age. Cool and analytic, these paintings are testimony to Sickert's capacity to turn his own distance and remoteness against himself with productive effect. All three images were made from photographs and transformed by Sickert's painter's hand into resonant meditations on death and old age. *The Servant of Abraham: Self-Portrait* (fig.56), transforms a rather powerful, flinty-eyed Sickert in the photograph on which it was based, into a disembodied head undergoing some alarming and passionate emotional turmoil. The lips now seem to pull themselves away from each other in some agony of utterance while the eyes are fixed on internal events. Wendy Baron reads the biblical story on which the title is based as evidence of Sickert's view of himself as 'an instrument of divine will, but to aesthetic rather than spiritual ends'.[23] But the translation of the face into a badge of suffering moves that reading towards a darker vision. The servant is also no longer the central actor, the leading role which Sickert loved to play, but a subordinate, no matter how important. Sickert places himself in a position he was always loath to occupy in reality and that act amounts to a self-questioning, a dark view of his achievement and the position he had come to.

Lazarus Breaks his Fast: Self-Portrait (fig.57), marks the moment when Sickert began to recover from the serious illness he suffered soon after his marriage to Thérèse Lessore. Sickert casts himself as the resurrected Lazarus, returned to life but feeble, aged beyond measure, hardly clinging onto life as he haltingly forces his head down towards the first taste of the nourishment he can now once again take into his body. It is an intensely vulnerable image, charged with pathos and the sense of barely maintained life force.

These two images of Sickert's decline in health, which seem so powerfully to convey his sense of failure or weariness before his continued existence, are completed by the final painting in the trio, *The Raising of Lazarus* (fig.58). According to contemporary sources, Sickert was struck by the delivery of a life-sized artists' model lay-figure to his Islington studio and initiated a complicated preparatory scheme for a painting. He had the lay-figure wrapped in a shroud by his local undertaker and then professionally photographed, with his friend Cicely Hay playing the part of Lazarus's sister, and himself, perched on a step-ladder, in the role of Christ, breathing life into the dead image. The composition necessitated two prints and Sickert had a composite made from the negatives to achieve the final distribution of actors within the design. *The Raising of Lazarus* announces Sickert's return to strength. Now, two years after his recovery, he is the giver of life. His capacity to imbue the dead paint and dead motif with life on the canvas is given a lurid and melodramatic cast

Right
55 *Self-Portrait in Grisaille* 1935
Oil on canvas
68.6 × 25.4
(27 × 10)
National Portrait Gallery, London

Right
56 *The Servant of Abraham: Self-Portrait* 1929
Oil on canvas
61 × 50.8 (24 × 20)
Tate

Below right
57 *Lazarus Breaks his Fast: Self-Portrait*
c.1927
Oil on canvas
76.2 × 63.5
(30 × 25)
Private collection

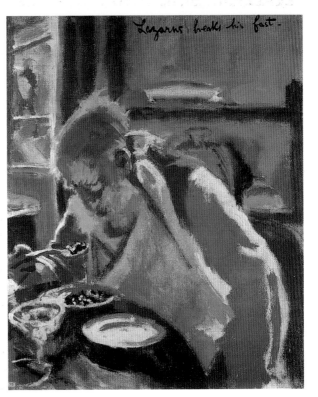

58 *The Raising of
Lazarus c.*1929
Oil on canvas
244.2 × 91.9
(96⅛ × 36⅛)
National Gallery of
Victoria, Melbourne:
Felton Bequest 1947

by the decision to set the whole composition within a powerful chiaroscuro. Sickert returns with some verve to the intense theatricality and impact Shone notes in many of his earlier works. The 'juvenile lead' is now indubitably senior, the focus once again of all the audience's eyes. Whatever its power, *The Raising of Lazarus* marks also the return of Sickert's irony and distance. *The Servant of Abraham* and *Lazarus Breaks his Fast*, however, remain as acknowledgements of the terror of the isolated self. Although *The Raising of Lazarus* asserts again, if a little ironically, the capacity of art to structure and form the world, later works of self-portraiture, from *Self-Portrait in Grisaille* to *Home Life* suggest a darkening view of the authority of the self and its isolation.

Sickert's final move was to Bathampton, just outside Bath, the city he and his second wife Christine had enjoyed so much during the First World War. He lived at Bathampton from 1938 until his death in 1942. The paintings he made there, with the help of Thérèse Lessore as he grew increasingly infirm, reinforce this intricate relationship between the found object of the photograph and the execution of the painter. Even though the principal hand in *Bathampton* (fig.59) was probably Lessore's, the compositional decisions which serve to insist on the capacity of paint to transform rather than merely transcribe the world were his.[24] *Bathampton* renders its pastoral subject in a restricted range of colours, predominantly reds and pinks and thus translates it, while preserving for many viewers the rhapsodic delight in the landscape associated with the genre, into a near-abstract and emphatically painted statement. One of Sickert's very last paintings, its insistence on the world of paint, Virginia Woolf's 'silent kingdom', as a domain where meaning and experience can be created and explored, make it a fitting end to his career.

59 *Bathampton*
*c.*1940–1
Oil on canvas
63.5 × 76
(25 × 29⅞)
Richard Salmon
Collection

CONCLUSION:
SICKERT AND HIS REPUTATION

Sickert from the first accumulated a substantial weight of critical commentary about him. His earliest critics, writing mainly for French newspapers in the years between the 1890s and 1910 saw him as above all a manipulator of paint, capable of striking refinement (to use their term) and sophistication, an exquisiteness of tonal value linked to a cool detachment 'à la Degas'.[1] That understanding of Sickert was current among the British public and critics as well, but there his painterly dandyism and refusal to provide straightforward narrative was seen as 'a little esoteric', something fit in the main only for the connoisseurs, the up-to-date and the '*raffinés*'.[2] This association with an ultra-sophisticated wing of the art world made Sickert's art in his early career one of limited popular appeal in Britain, something compounded by his prolonged absences in Dieppe. It was not until the advent of the Camden Town Group in 1911 that, partly as a result of the ferment of interest in 'advanced' and 'modernist' art which was brewing up in the few years before the First World War, Sickert began to be seen as a leading figure, 'a considerable master', whose influence was discernable in younger artists who looked to him to lead revolutionary artistic developments.[3] Sickert's independence and originality were now widely recognised and the uniqueness of his distinctive subject matter, the music halls and ordinary lives lived out in the bed-sitting rooms and pubs of North London was understood as a central contribution to the development of modern English painting. Even though critics remained inclined to revolt against it as 'dingy', 'sordid' and even 'hideous', they also increasingly saw this art as a self-conscious and deliberate realism through which 'beauty' was discovered in the mundane. There is considerable emphasis at this time on Sickert's 'sincerity' as the poet of the everyday even where his subject matter was perceived as difficult or repellent. The flip side of this, slightly grudging, praise, was a widespread feeling among the commentators that Sickert's insights into modern life were in part the result of a lack of imagination, that his work was accurate and sincere but no more than a transcript of what he saw. At the same time, other critics (and sometimes the same ones) were irritated by Sickert's 'cleverness', those qualities of refinement and sophistication which his earliest commentators had identified.

A painter who prompted such uncertainty in his audience was courting unpopularity and, although respected, Sickert was not seen as ever likely to win a popular or very wide audience for his work. Perhaps because of this, Sickert's withdrawal from the position of leader during the art wars of the 1910s, the impact of the real war which followed, and his breakdown in health in the early 1920s had little effect on his reputation. In 1920 John Middleton Murry was writing that 'Mr Sickert has come to be regarded as a safe thing by

those fortunate people who are wealthy enough to be picture-buyers'.[4] His position as an influential 'father' to the modern movement in England was acknowledged and the integrity of his art reaffirmed, so that by the mid-1920s, when he was elected as an ARA, press reviewers agreed on Sickert's importance, individuality as an artist and role as a senior figure on the English art scene.

Perhaps unsurprisingly, this upward turn in Sickert's reputation produced rumours of forged Sickerts for sale in London during the mid-1920s as well as a rise in saleroom prices. When *The New Bedford* went for 180 guineas in January 1927 it was the highest price a Sickert painting had fetched and reflected a rise in commercial interest in his work from about 1925, that is from immediately after he became an ARA. On 7 July 1928, the *Daily Telegraph* reported that Sickert's saleroom average price had risen from 'less than 110 gns' to new heights as the result of prices of 400 guineas, 270 guineas, and 320 guineas following the *New Bedford* sale. The developing 'Sickert legend' and the enthusiastic press reportage of it, together with his access of energy and productiveness in the late 1920s raised his reputation farther. 'Rather late in the day people are discovering that Walter Sickert is a great painter,' wrote the *Weekly Despatch* in 1928, it 'makes the discerning wonder why public recognition has been so long in coming'.[5] And in 1929, reviewing Sickert's retrospective at the Leicester Galleries, under the subtitle 'a genius who was long ignored', the *Daily Herald* announced 'the unquestionable genius of a great master'.[6] By the late 1920s Sickert was the subject of laudatory articles in *Apollo*, the *New Statesman* and other leading journals. 'As I came away from the Sickert exhibition', wrote a critic for *Apollo* of the Leicester Galleries retrospective, 'a phrase flashed across my mind unbidden: here it is: This is one of painting's Old Masters.'[7]

It was therefore into a very welcoming climate of opinion that Sickert introduced the 'Echoes' when he started to show them in the early 1930s. From the first they were well received. 'The exhibition places Mr Sickert in the front rank of contemporary European painters,' wrote the influential art journal the *Studio*, and the *Daily Telegraph* thought it confirmed his status as 'not only the best living artist in England, but one of the best in the world'.[8] There was hardly a dissenting voice as critics praised Sickert for his essential painterliness, his fluency, skill and sophistication of touch, and urged his status as a distinguished colourist. In many ways this marks the high point of Sickert's critical reception, for he never before or afterwards received such a unanimous stream of praise from the commentators. Less impressed by Sickert's use of photography than by the 'Echoes', critics started to wonder as the 1930s wore on whether Walter had not been a rather better painter than Richard, that is whether late Sickert was perhaps not so strong as early. Nonetheless, the work based on photographs was frequently highly praised. *Gwen Ffrangçon-Davies as Queen Isabella* was widely received as a masterpiece in 1932 and the *Viscount Castlerosse* was portrait of the year at the Royal Academy in 1935. To the *Guardian* in the early 1930s Sickert seemed 'beyond criticism'.[9]

Between the mid-1930s and the lifetime retrospective at the National Gallery in 1941, the praise becomes a little attenuated and, perhaps with the

feeling that this was an opportunity to judge for posterity, there were dissenting voices among those making final evaluations of Sickert. The most significant of these were Clive Bell, who called him 'a very good painter' but not in the European context 'a great artist', and Michael Rothenstein who discerned a lack of conviction in the late work.[10] But in general the show was respectfully received and Raymond Mortimer's comment that he was 'much the greatest English painter since Turner' summed up the general sense that Sickert's status as a modern master was secure.[11]

Since his death Sickert has been fortunate to have been the subject of some of the best scholarship devoted to English art of his period. Wendy Baron's scholarly volumes *Sickert* (1973) and *The Camden Town Group* (1979) stand out, as does the 1981 Art's Council exhibition catalogue *Late Sickert*, which helped to rehabilitate Sickert's output after the late 1920s at a time when it had become eclipsed by his early work. The presence of a powerful account of Sickert's life in Robert Emmons's 1941 biography and the regular exhibitions of Sickert's works at dealers, together with the collection of his writings which appeared in 1947, and the biography of Denys Sutton (1976), equipped those seeking information about Sickert with an impressive array of scholarship and information. The quality of these studies and of those by Marjorie Lillie (1971) and Richard Shone (1988) helped to maintain and develop interest in Sickert. This culminated in the magnificent 1992 exhibition catalogue by Wendy Baron and Richard Shone for the Royal Academy show of Sickert's paintings held in that year. More recently, there have been signs of a desire on the part of commentators to develop new perspectives through which to understand Sickert and his works. Reviewing the 1992 Royal Academy catalogue in 1994, Andrew Stephenson in an important statement called for attention to a new range of issues in studies of Sickert's work. Stephenson argued that Sickert scholarship needed to place the painter in the context of concerns arising from the 'transformations of social, political and sexual relationships taking place in metropolitan culture in Britain in the late nineteenth and early twentieth centuries', including new versions of sexual identity which affected male artists, his 'ambivalence … about developing forms of mass culture' in the music-halls and in London itself, and what Stephenson happily calls his 'preoccupation with the "modern" as precarious and visually estranged'.[12] Anna Gruetzner Robins's 1996 book on the drawings performed a valuable service by taking up some of these new questions and discussing Sickert in relation to issues of gender, and new art-historical concerns at length for the first time.[13] At the start of a new century Sickert looks secure. Interest in his work among both art historians and the public continues to be strong, with new publications, including a new biography and the edition of the complete writings compiled by Anna Gruetzner Robins, on their way. There is every indication that Sickert's art contains the necessary ingredient which recommends painters to posterity. As we continue to ask new questions of it, the art continues to provide us with answers. It is vivid, flexible, enigmatic and suggestive enough to speak to us of our latest as well as our most longstanding concerns.

I began this book by presenting Sickert as an ironist. Constitutionally

aware of how ill he fitted into his adoptive country of England, his love for it expressed itself through the medium of a distant, almost disengaged self which was intimate and withdrawn simultaneously. I ended by celebrating Sickert's life-long fascination with the physical properties of paint itself, paint as a substance, a material slice of the world through which and in which a particularly visual form of thinking and analysis went on. In between I suggested that the enigmatic and indeterminate subjects of many Sickert paintings, their resistance to easy narrative reading, are expressed through this fascination with paint. The difficulty of articulating our normal way of knowing the world through paint mirrors, in the late 'Echoes' as much as in the Camden Town Murder series, the uncertainty about the meanings of experience which modern life brought with it. Sickert's refusal of clear answers and positions throughout his life resonates with our own felt complexity and inability to make firm statements about the lives we lead. His protean self, whether expressed through choice of name, appearance, location, or through his concerns as a painter, stands for us as a compelling example of reflection upon our modern existence.

Chronology

The information given here is largely derived from Wendy Baron's extended chronology in Wendy Baron and Richard Shone (eds.), *Sickert: Paintings*, exh. cat., Royal Academy of Arts, London 1992, to which the reader is referred for a fuller account of Sickert's life and activities in this form. I have also relied on Robert Emmons, *The Life and Opinions of Walter Richard Sickert* (1941) and Denys Sutton's biography, *Walter Sickert* (1976).

1860 Sickert was born on 31 May in Munich, the eldest son of the Danish painter and illustrator Oswald Adalbert Sickert and of Eleanor Sheepshanks whose origins were English and Irish.

1868 The Sickerts moved from Germany to Britain and settled in Bedford.

1869–78 The family moved to London, settling in Notting Hill where the last of the six children were born, and later moving to Kensington. Sickert attended University College School, Bayswater Collegiate School and King's College School, leaving in 1878 after a successful scholastic career.

1878–80 Sickert began a career as an actor, touring with a number of companies.

1879 Met Whistler and continued to make occasional paintings.

1881 Exhibited his first work, *Loch: Sutherlandshire* (lost) and registered at the Slade School of Art.

1882 Left the Slade at Whistler's instigation to become his studio assistant.

1883 Travelled to Paris for Whistler with letters of introduction to Manet (who was too ill to see him) and Degas whose studio he visited.

1884–5 Exhibited as 'pupil of Whistler' at the Society for British Artists.

1885 Married Ellen Melicent Cobden (1848–1914), daughter of the influential Victorian MP Richard

Cobden, and visited Europe where Sickert met Degas again. The Sickerts returned to Paris to visit Degas later in the year and Sickert's works begin to show the influence of Degas.

1886 First one-man exhibition at Dowdeswell's Gallery in London.

1887 Exhibited by invitation with Les XX in Brussels. Sickert began to paint the music-hall.

1887–8 Joined the New English Art Club and was elected member of the Society of Painter-Etchers. According to Wendy Baron at this time Sickert began to act more independently of Whistler.

1889 'London Impressionists' exhibition at the Goupil Gallery, London with colleagues including Philip Wilson Steer, Fred Brown and Theodore Roussel. Sickert showed works including music-hall scenes.

1890 Advertised the first of many art schools under his tuition. Began to write art criticism and commentary, an activity he continued up to the end of his career.

1891–3 Spent the summers in Dieppe.

1893–4 Briefly ran the Chelsea Life School.

1895 Sickert made an extended trip to Venice.

1896 Separated from his wife and spent further time in Venice.

1897 End of Sickert's relationship with Whistler. The immediate cause was a court case involving comments Sickert had made about the technique of transfer lithography to which Whistler took exception.

1898 Moved permanently to Dieppe, where he had been a regular visitor for some years.

1899 Divorced from Ellen Cobden.

1900 Briefly in Dieppe and in Venice.

1903 Exhibited at the Société Nationale in Paris.

1904 Extended stay in Venice. One-man exhibition at Bernheim Jeune in Paris.

1905 Moved back to London permanently and took rooms in Mornington Crescent, Camden Town.

1906 Trip to paint the Paris music-halls.

1907 Exhibition at Bernheim Jeune. The informal Fitzroy Group was founded to promote the work of the membership including William Rothenstein, Spencer Gore, Harold Gilman, Nan Hudson, Ethel Sands and Sickert. Began to use the 'Camden Town Murder' title for works he produced.

1908 Instrumental in the foundation of the Allied Artists' Association, an exhibiting group without jury. Sickert began a long exhibiting history with the AAA.

1909 Exhibition at Bernheim Jeune. Founded what became his longest-lasting art school, Rowlandson House (1909–14).

1911 One-man exhibitions at the Carfax Gallery and Stafford Gallery, London. The Camden Town Group formed with sixteen members including Harold Gilman, Charles Ginner, Spencer Gore, Wyndham Lewis and Sickert. The Group's first and second exhibitions at the Carfax Gallery. Sickert married his second wife, Christine Angus in July this year.

1912 Third Camden Town Group exhibition.

1913 Exhibited at the Armory Show, New York. Sickert and his wife moved to Envermeu near Dieppe where they had a house built. Sickert contributed to the exhibition of Post-Impressionist and Futurist art held at the Doré Gallery, London. The Camden Town Group was expanded, becoming the London Group the following year. The first exhibition was held at Brighton in 1913–14 as 'English Post-Impressionists, Cubists and Others'.

1914 Sickert resigned from the London Group and the Fitzroy Street Group. Signed an exclusive contract with and held a one-man show at the Carfax Gallery. In Envermeu and then Dieppe at the start of the First World War, returning to London in late August. Began to etch as his main activity.

1915 Worked at etching at his Red Lion Square studio. Recent etchings were published by the Carfax Gallery. He and his wife spent time in Devon during the summer.

1916 Rejoined the London Group and exhibited with them, held a one-man show at the Carfax Gallery and visited Bath.

1917 Exhibited with the London Group before resigning again.

1918 Withdrew from his Carfax agreement and seems to have spent most of the latter part of the year in Bath.

1919 One-man exhibition at the Eldar Gallery, London. Sickert and his wife left England for Envermeu where they intended to settle permanently.

1920 Christine Sickert died in November and Sickert moved to Dieppe.

1921 Continued to paint in Dieppe as he had been doing since 1919.

1922 Sickert's mother died. He moved back to London.

1923 Rejoined the London Group, with whom he had exhibited as a non-member several times over the previous years. Gave his lecture 'Straws from Cumberland Market, in Edinburgh and Oxford.

1924 Continued to deliver 'Straws from Cumberland Market' and held an exhibition at the Independent Gallery, London. In December Sickert was elected an Associate of the Royal Academy.

1925 Sickert was elected an Associate of the Royal Society of Painters, Etchers and Engravers and held an exhibition of etchings at the Leicester Galleries, London. Exhibited at the Royal Academy. According to Wendy Baron he 'called himself Walter Sickert in

February and March, Walter Richard Sickert from April until the autumn, when he first wrote under the name Richard Sickert'.

1926 Started a short-lived art school, 'The Sickert Atelier', in Manchester. Exhibitions of drawings at the Savile Gallery and Dover Gallery, London. In June Sickert married Thérèse Lessore whom he had known for a long time. Sickert took a studio in Brighton after the wedding but suffered what Wendy Baron calls a 'serious breakdown in health ... possibly a stroke' at the end of the year.

1927 According to Wendy Baron 'finally adopted his second name of Richard for all purposes'. Founded his last art school, this time in Islington. Exhibition of drawings at the Savile Gallery. Began his series of 'Echoes' and by now 'painted almost exclusively from photographs' (Baron). Sickert was elected President of the Royal Society of British Artists and resigned the following year.

1928 Several retrospective exhibitions through the year, at the Savile Gallery, with the London Group retrospective, at the exhibition of Modern British Art held at Brussels and at the Leicester Galleries.

1930 Exhibition at the Savile Gallery of drawings and paintings and in the British section of the XVIIth Biennale in Venice as well as at the Galerie Cardo in Paris.

1931 Exhibition of 'English Echoes' at the Leicester Galleries.

1932 Exhibition at the Beaux Arts Gallery, London. Sickert was awarded an Honorary Doctorate of Law by Manchester University. He exhibited at the XVIIIth Venice Biennale and had an 'Echo' bought by the Louvre.

1933 A number of exhibitions, including at the Beaux Arts Gallery and at the Royal Academy and a major loan exhibition at Agnew's, London.

1934 Virginia Woolf's *Walter Sickert: A Conversation* was published and Sickert was elected a Royal Academician. Sickert at this time

received help from various friends and well-wishers to mitigate his difficult financial straits. He moved with his wife to St-Peter's-in-Thanet, Broadstairs, Kent in the Autumn of this year.

1935 Exhibited at the Royal Academy but resigned in May in defence of Jacob Epstein. Exhibited at the Beaux Arts Gallery and the Walker Art Gallery in Liverpool.

1936 Retrospective of the early paintings at the Redfern Gallery, London and of recent works at the Leicester Galleries. Sickert also showed at the British Art exhibition in Amsterdam this year.

1937 Exhibitions at the Adams Gallery, London, the Redfern and the Beaux Arts Gallery. Sickert was elected a corresponding member of the Académie des Beaux-Arts of the Institut de France.

1938 Sickert's works were shown in a retrospective at Chicago and then the Carnegie Institute in Pittsburgh and in an exhibition of English paintings held at the Louvre. He also had an exhibition at the Leicester Galleries. Sickert was awarded a Doctorate of Letters by the University of Reading and ended this year by moving to St George's Hill House, Bathampton outside Bath.

1939 Sickert lectured at Bath School of Art and had paintings in exhibitions at the Beaux Arts Gallery and at the Galerie Bing in Paris and the World's Fair, New York.

1940 Exhibitions at the Redfern Gallery and the Leicester Galleries. W.H. Stephenson, who had been a patron of Sickert's, published *Sickert: The Man and his Art. Random Reminiscences*.

1941 The National Gallery held a major exhibition of 132 paintings and drawings curated by Lilian Browse. Robert Emmons published *The Life and Opinions of Walter Richard Sickert*.

1942 Sickert dies on 22 January at Bathampton. He is buried there with Thérèse Lessore who died in 1945.

Notes

References to material held in the Sickert archive in Islington Libraries Local History Collection are given in the form IC. The volumes of press cuttings are identified as PCB followed by the dates covered by the volume and, where one exists, by the folio number.

Introduction

1 Osbert Sitwell, *Noble Essences, or Courteous Revelations: Being a Book of Characters and the Fifth and Last Volume of Left Hand, Right Hand!, an Autobiography*, London 1950, pp.199, 201.

2 Jacques-Emile Blanche, *More Portraits of a Lifetime 1918–1938*, trans. Walter Clement, London 1939, p.117.

3 Wendy Baron, *Sickert*, London 1973, p.170.

4 *Daily Express*, 5 June 1929, IC PCB, 1915–41: 55.

5 Virginia Woolf, *Walter Sickert: A Conversation*, with an introduction by Richard Shone, London 1992, p.17.

Chapter 1

1 Deanna Marohn Bendix, *Diabolical Designs: Paintings, Interiors and Exhibitions of James McNeill Whistler*, exh. cat., Washington and London 1995, p.11.

2 See Aimée Troyen, *Walter Sickert as Printmaker*, exh. cat., New Haven 1979, pp.4–5, and Ruth Bomberg, *Walter Sickert: Prints, A Catalogue Raisonné*, New Haven and London 2000. My discussion is indebted to both.

3 Sickert first exhibited under this title, see Robert Emmons, *The Life and Opinions of Walter Richard Sickert*, London 1941, pp.32, 92.

4 Charles Ricketts, 'G. F. Watts', *Pages on Art*, London 1913, p.110.

5 James McNeill Whistler, 'The Ten O'Clock Lecture' [delivered 1885], in Eric Warner and Graham Hough (eds.), *Strangeness and Beauty: An Anthology of Aesthetic Criticism 1840–1910, II, Pater to Symons*, Cambridge 1983, p.81.

6 Richard Shone, *Walter Sickert*, Oxford 1988, p.20.

7 Walter Sickert, 'From "Where Paul and I Differ" ' [1910], in Osbert Sitwell (ed.), *A Free House! or the Artist as Craftsman, Being the Writings of Walter Richard Sickert*, London 1947, p.22.

8 See T.J. Clark, *The Painting of Modern Life: Paris in the Art of Manet and his Followers*, London 1985.

9 Mortimer Menpes, *Whistler as I Knew Him*, London 1904, pp.24–5, 21.

10 Walter Sickert, 'Whistler: The Artist in Practice' [letter], *The Times* [no date or issue given], IC PCB, 1906–9, June 1934–8 [n.p.]. This argument is part of his repudiation of Whistler; see also, *A Free House!*, p.15.

11 Walter Sickert, 'Introduction to the Catalogue of the "London Impressionists" Exhibition' [1910], reprinted in D. S. MacColl, *Life, Work and Setting of Philip Wilson Steer*, London 1945, p.176.

12 *Pall Mall Gazette*, IC PCB, 1906–9 [n.p.]; W. H. Meyers, *Onlooker* (22 July 1911), IC PCB, 1906–9: 2; *Saturday Review* (1 Dec. 1906), IC PCB, 1906–9 [n.p.]; Claude Phillips, 'Goupil Gallery: Contemporary Art Society', *Daily Telegraph* (7 April 1913), IC PCB, 1908–14: 102.

13 Blanche, *More Portraits*, p.117.

14 *Pall Mall Gazette*, 9 Jan. 1908.

15 Wendy Baron and Richard Shone (eds.), *Sickert: Paintings*, exh. cat., London 1992, p.106.

16 Albert Rutherston, cited in Denys Sutton, *Walter Sickert: A Biography*, London 1976, p.126.

17 *Sickert: Paintings*, p.136.

Chapter 2

1 See Richard Shone, *Walter Sickert*, p.45.

2 Cited in *Sickert: Paintings*, p.9.

3 *Studio*, 1929, IC PCB, 1915–41: 66 (reverse).

4 *A Free House!*, p.277.

5 See Richard Shone, 'Walter Sickert, the Dispassionate Observer', *Sickert: Paintings*, pp.1–11.

6 J.B.M., 'Camden Town Comedies', *Outlook*, 8 June 1912, IC PCB, 1908–14: 78.

7 See Wendy Baron, 'Introduction' in *Sickert: Paintings, Drawings and Prints of Walter Richard Sickert 1860–1942*, exh. cat., London 1977–8.

8 See Anna Gruetzner Robins, *Walter Sickert Drawings, Theory and Practice: Word and Image*, Aldershot 1996.

9 *A Free House!*, p.43.

10 Walter Sickert, 'Idealism', *The Art News*, 12 May 1910, p.217.

11 Ibid.

12 'The Study of Drawing', *The New Age*, 16 June 1910, p.156

13 Ibid.

14 Cited *Sickert: Paintings*, p.198, where the location is also identified.

15 *Sickert: Paintings*, p.206. See also Lisa Tickner, *Modern Life and Modern Subjects*, New Haven and London 2000.

16 Cited *Sickert: Paintings*, p.206.

17 Robins, *Walter Sickert: Drawings*, p.33.

18 According to R. H. Wilenski, *Sickert, Edited by Lillian Browse with an Essay on his Life and Notes on his Paintings; and with an Essay on his Art by R. H. Wilenski*, London 1943, p.29.

19 Emmons, *Life and Opinions*, p.9.

20 Woolf, *Walter Sickert*, p.23.

21 *Morning Post*, 19 July 1911

Chapter 3

1 *Sickert: Paintings*, p.222.

2 Desmond MacCarthy, [1943], cited in Anna Gruetzner Robins, *Modern Art in Britain 1910–1914*, exh. cat., London 1997.

3 *Illustrated London News*, 15 July 1911.

4 See Charles Harrison, *English Art and Modernism 1900–1939*, London and Bloomington 1981, ch.2.

5 *Pall Mall Gazette*, 11 March 1914.

6 Walter Sickert, 'A Perfect Modern', *The New Age*, 9 April 1914.

7 Cited *Sickert: Paintings*, p.240.

8 'Three Remarkable Works', *Morning Post*, 2 Dec. 1914, IC PCB, 1908–14: 141; *Athenaeum*, IC PCB, 1908–14: 142.

9 *Sickert: Paintings*, p.240.

10 Ibid.

11 Ibid.

12 Cited in Baron, *Sickert*, pp.135–6.

13 Stephen Hackney, 'Walter Sickert (1860–1942): *Brighton Pierrots* 1915', in Stephen Hackney, Rica Jones and Joyce Townsend (eds.), *Paint and Purpose: A Study of Technique in British Art*, London 1999, p.120.

14 See Troyen, *Walter Sickert as Printmaker*, pp.50–1; Bomberg, *Walter Sickert: Prints*, pp.26–34.

15 Troyen, *Walter Sickert as Printmaker*, p.50.

16 Cited in Baron, *Sickert*, p.156.

17 Ibid.

18 *Sickert, Edited by Lillian Browse*, p.17; V. Overton Fuller, unpublished typescript, Islington Public Libraries.

19 Sutton, *Walter Sickert*, p.207.

20 *A Free House!*, p.32. Cf. Anna Gruetzner Robins, 'Leighton: A Promoter of the New Painting', in Tim Barringer and Elizabeth Prettejohn, *Frederic Leighton: Antiquity, Renaissance, Modernity*, New Haven and London 1999.

21 *Manchester Evening Guardian*, 15 Nov. 1924; *Morning Post*, 25 November 1924; *Nation and Athenaeum*, 29 Nov. 1924.

22 *Sickert: Paintings*, p.276.

Chapter 4

1 Walter Sickert, 'Straws from Cumberland Market' [1924], cited in Emmons, *Life and Opinions*, p.247.

2 *Sickert: Paintings*, p.308.

3 Walter Sickert, letter to Leicester Art Gallery, 1931, reprinted in *Late Sickert: Paintings 1927 to 1942*, exh. cat., London 1981, p.102.

4 Cited *Sickert: Paintings*, p.308.

5 Walter Sickert, catalogue notes to Leicester Galleries show 'English Echoes', May 1931, reprinted in *Late Sickert*, pp.103, 102.

6 Catalogue notes to 'English Echoes', reprinted in *Late Sickert*, p.103.

7 Ibid.

8 Letter to Leicester Art Gallery, reprinted in *Late Sickert*, p.102.

9 Emmons, *Life and Opinions*, p.179.

10 Cited, *Sickert: Paintings*, p.310.

11 *Sickert: Paintings*, p.288.

12 Cf. Walter Benjamin, 'The Work of Art in the Age of Mechanical Reproduction', in *Illuminations*, London 1973.

13 'Mr Sickert's Latest', *Observer*, 5 June 1932, IC PCB, 1915–41: 148 (reverse).

14 James Elkins, *What Painting Is*, New York and London 2000, p.5.

15 Walter Sickert, 'Art at Oxford' [letter], *Morning Post*, 13 June 1922, IC PCB, 1915–41: 26.

16 Cited in *Sickert: Paintings*, p.322.

17 *Sickert: Paintings*, p.320.

18 *Sickert: Paintings*, p.322, and see also Richard Morphet, 'Late Sickert, Then and Now' in *Late Sickert*, pp.8–21

19 Cited in *Sickert: Paintings*, p.316.

20 See, on Sickert's paint surface, Morphet, 'Late Sickert', pp.15–16.

21 *Sickert: Paintings*, p.338.

22 Morphet, 'Late Sickert', p.12.

23 *Sickert: Paintings*, p.290.

24 See *Sickert: Paintings*, p.350.

Conclusion

1 François Monod, *Art et Decoration*, July 1909, IC PCB, 1908–14 [n.p.].

2 *Westminster Gazette*, Jan. 1910, IC PCB, 1908–14 [n.p.].

3 G.R.H., 'Mr Sickert's Exhibition', *Pall Mall Gazette*, 12 July 1911, IC PCB, 1908–14: 8.

4 John Middleton Murry, 'Art: Mr Walter Sickert's Paintings', *Nation*, 24 July 1920, IC PCB, 1915–41: 21 (reverse).

5 'Sickert's Best', *Weekly Despatch*, 12 February 1928, IC PCB, 1923–8: 83.

6 G.G.S., 'Artist of Life as It Is: A Genius Who Was Long Ignored', *Daily Herald*, 5 June 1929, IC PCB, 1915–41: 55

7 'Sickert Retrospective Exhibition at the Leicester Galleries', *Apollo* 1929, IC PCB, 1915–41: 63 (reverse).

8 'Mr Richard Sickert ARA, *Studio*, May 1930, PCB: 1915–41: 92; 'Sickert's Mastery of Colour', *Daily Telegraph*, 4 March 1930, IC PCB, 1915–41: 87.

9 'Mr Sickert and the Photogra-
 phers', *Guardian*, 16 Sept. 1932,
 IC PCB, 1915–41: 157.

10 Clive Bell, *New Statesman and
 Nation*, 6 Sept. 1941, IC PCB,
 1915–41: 189; Michael Rothen-
 stein, 'Sickert Exhibition at
 National Gallery', *World Review*,
 Oct. 1941, IC PCB, 1915–41: 190.

11 Raymond Mortimer, 'Sickert at
 the National Gallery', *Listener*,
 28 Aug. 1941, IC PCB, 1915–41:
 187.

12 Andrew Stephenson, 'Buttress-
 ing Bohemian Mystiques and
 Bandaging Masculine Anxi-
 eties', *Art History*, 17: 2 (June)
 1994, p.276.

13 Anna Gruetzner Robins, *Walter
 Sickert: Drawings*, p.33.

Select Bibliography

Baron, Wendy, 'Sickert's Links with French Painting', *Apollo*, March 1970.

Baron, Wendy, *Sickert*, London 1973.

Baron, Wendy, *The Camden Town Group*, London 1979.

Baron, Wendy, 'Sickert and the Camden Town Murder', *Art at Auction: The Year at Sotheby Parke Bennett 1979–80*, ed. Joan A. Speers, London 1980.

Baron, Wendy and Richard Shone (eds.), *Sickert: Paintings*, exhib. cat., Royal Academy of Arts, London in association with Yale University Press, New Haven and London 1992.

Bromberg, Ruth, *Walter Sickert: Prints, A Catalogue Raisonné*, New Haven and London 2000.

Browse, Lillian (ed.), with an essay by R. H. Wilenski, *Sickert*, London 1943.

Browse, Lillian, *Sickert*, London 1960.

Corbett, David Peters, '"Gross Material Facts": Sexuality, Identity and the City in Walter Sickert 1905–1910', *Art History*, vol.21, no.1, March 1998.

Dempsey, Andrew, 'Whistler and Sickert: A Friendship and its End', *Apollo*, vol.83, Jan. 1966.

Easton, Malcolm (ed.), *Sickert in the North*, exhib. cat., University of Hull 1968.

Emmons, Robert, *The Life and Opinions of Walter Richard Sickert*, London 1941.

Lilly, Marjorie, *Sickert: The Painter and his Circle*, London 1971.

Morphet, Richard, 'The Modernity of Late Sickert', *Studio International*, vol.140, 1975.

Morphet, Richard, *et al.*, *Late Sickert: Paintings 1927 to 1942*, exhib. cat., Hayward Gallery, London, Arts Council, London 1981.

The Painters of Camden Town 1905–1920, exhib. cat., Christies, London 1988.

Robins, Anna Gruetzner, 'Degas and Sickert: Notes on their Friendship', *Burlington Magazine*, vol.130, 1988.

Robins, Anna Gruetzner, *Walter Sickert: Drawings: Theory and Practice: Word and Image*, Aldershot 1996.

Robins, Anna Gruetzner, *Walter Sickert: The Complete Writings on Art*, Oxford University Press 2000.

Shone, Richard, *Walter Sickert*, Oxford 1988.

Sickert: Centenary Exhibition of Pictures from Private Collections, exhib. cat., Thomas Agnew, London 1960.

Sickert: Paintings, Drawings and Prints of Walter Richard Sickert 1860–1942, exhib. cat., Arts Council, London 1977.

The Sickerts in Islington: Catalogue of the Works of Walter Sickert, Thérèse Lessore and their Families in Islington Libraries Local History Collection, Islington 1987.

Sickert, Walter, *A Free House! or the Artist as Craftsman, being the Writings of Walter Richard Sickert*, ed. Osbert Sitwell, London 1947.

Shanes, Eric, *Impressionist London*, New York, London and Paris 1994.

Stephenson, Andrew, 'Buttressing Bohemian Mystiques and Bandaging Masculine Anxieties', *Art History*, vol.17, no.2, 1994.

Sutton, Denys, *Walter Sickert*, London 1976.

Troyen, Aimée, *Walter Sickert as Printmaker*, exhib. cat., Yale Center for British Art, New Haven 1979.

Wedmore, Frederick, *Some of the Moderns*, London 1909.

Woolf, Virginia, *Walter Sickert: A Conversation*, ed. Richard Shone, London 1992.

W. R. Sickert: Drawings and Paintings 1890–1942, exhib. cat., Tate Gallery Liverpool 1989.

Photographic credits

Copyright Credits

Index